OXFORDSHIRE

THROUGH TIME

Stanley C. Jenkins

AMBERLEY PUBLISHING

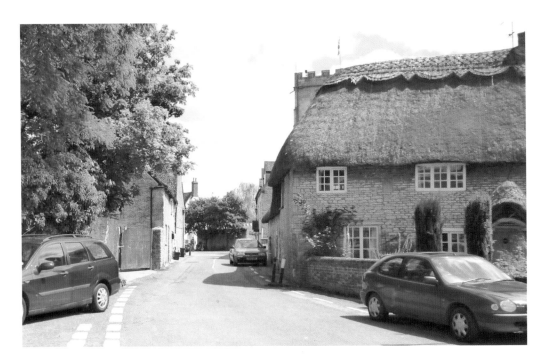

Eynsham: Old Houses

Eynsham, to the west of Oxford, contains many picturesque, Cotswold-style houses, as shown in this recent view of Swan Street.

First published 2013

Amberley Publishing
The Hill, Stroud, Gloucestershire, GL5 4EP
www.amberley-books.com

Copyright © Stanley C. Jenkins, 2013

The right of Stanley C. Jenkins to be identified as the Author of this work has been asserted in accordance with the Copyrights, Designs and Patents Act 1988.

ISBN 978 1 4456 1707 7 (print)
ISBN 978 1 4456 1716 9 (ebook)

British Library Cataloguing in Publication Data.
A catalogue record for this book is available from the British Library.

Typesetting by Amberley Publishing.
Printed in Great Britain.

Introduction

Oxfordshire came into existence during the tenth century – Oxford being laid out as one of the fortified 'burghs' which King Alfred and his descendants employed in their campaign against the Danes. At that time, Alfred's son Edward the Elder and his daughter Aethelflaed were slowly, but inexorably, recovering English territory from the Danes. Aethelflaed was the widow of a Mercian nobleman who had been entrusted with the defence of London, and it is likely that she would have employed her father's engineers to lay out the new burgh at Oxford. Although there was already a minster church and a small pre-existing settlement in the vicinity, the new town was on an immeasurably greater scale; for that reason Lady Aethelflaed can be seen as the founder of Oxford.

The new 'burgh' was built at a crossing point on the River Thames. It was well situated for defensive purposes, and occupied a location between the Thames and the River Cherwell. The surrounding marshes provided natural defensive features, while the burgh itself was encircled by stockaded banks and stone-faced ramparts. The new urban centre prospered and, despite a destructive Danish attack in 1002, this West Saxon stronghold developed into a prosperous and thriving county town.

Oxford became a recognised centre of learning during the twelfth century. As the number of students increased, hostels or 'halls' were opened to accommodate them, while benefactors began to found endowed colleges, which were self-governing and tended to be much larger than the halls. It is estimated that there were, in the mid-fifteenth century, around seventy halls in Oxford, together with ten colleges, though in the fullness of time, further colleges were founded, many of the earlier halls being absorbed or converted into the new collegiate foundations. By 1852, there were nineteen colleges and five halls at Oxford, whereas today there are thirty-eight colleges and six private halls.

The original county was, in general, confined to the north side of the River Thames, although in 1974 the Vale of White Horse district was transferred from Berkshire to Oxfordshire, and the county thereby gained a considerable amount of new territory on the south side of the river.

The scenery within the Oxfordshire area is dictated by the underlying geology which, generally speaking, consists of a Cotswold-style limestone plateau in the north, and a chalk escarpment in the south, the limestone and chalk districts being separated by an intervening belt of low-lying Oxford clay, which crosses the county from west to east. The limestone area contains two sections; the southern part being composed of honey-grey oolitic limestone but, as one travels north-eastwards, the oolitic limestone is replaced by a plateau of Middle Lias or Marlstone – a sandy, ferruginous, rust-brown limestone, often referred to as 'ironstone'. The limestone district has many affinities with the Gloucestershire Cotswolds, whereas the chalk area is, in effect, an extension of the Buckinghamshire Chilterns.

Oxfordshire is a predominantly rural county, although Oxford, by far the largest town, developed as an important car-making centre, with two large factories in the industrial suburb of Cowley. Banbury acquired an aluminium rolling mill, and Witney was, until the demise of its last textile mill in 2002, a famous blanket-making town. In 1931, Oxford had a population of 209,599 and Banbury had 13,953 inhabitants; the next largest town was Henley-on-Thames,

with a population of 6,618, while the smaller towns of Bicester, Witney, Chipping Norton and Thame had between 3,000 and 6,000 inhabitants.

It is impossible, in a small volume such as this, to encompass every town and village within the county, and after much consideration it was decided that the Vale of White Horse would be excluded in its entirety – in historical terms, this area is, after all, part of Berkshire. On the other hand, an attempt has been made to include representative towns and villages from all of Oxfordshire's main geographical areas; for example, Witney, Woodstock, Eynsham, Burford and the surrounding villages represent the Oxfordshire Cotswolds, while Adderbury, Banbury, Deddington and Great Tew represent the Banbury 'ironstone' district. A number of south Oxfordshire locations have been described, including Watlington, Clifton Hampden, Nuneham Courteney, Warborough, Shillingford, Dorchester and Henley-on-Thames. Finally, Oxford is covered in some detail, together with Bicester and Caversfield in the east of the county. In all, some thirty-nine different locations have been included in this present volume.

Acknowledgements

Thanks are due to Diana Lydiard (pp. 7, 8, 11, 14, 23, 39, 47, 65, 67, 68, 69, 70, 72, 73 & 76), Michael French (pp. 40 & 91), Ingram Murray (p. 75), Robbie Robinson (pp. 12 & 13), John Drummond (p. 85), Mike Marr (p. 86), Martin Loader (pp. 37 & 65) and Dino Lemonofides (pp. 21, 22, 23 and 24), for help with the supply of photographs for this book. Other images were obtained from the Witney & District Museum and from the author's own collection.

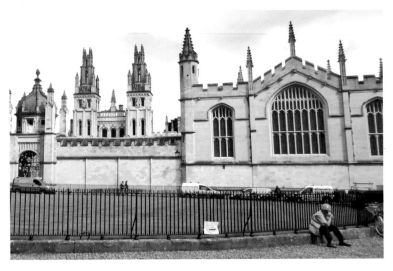

All Souls College, Oxford
A view of All Souls College from Radcliffe Square. All Souls was founded in 1438 as a college and chantry, in which masses would be held for the souls of those who had died in the Hundred Years War. These buildings form part of the North Quad, which was designed by Nicholas Hawksmoor (c. 1662–1736).

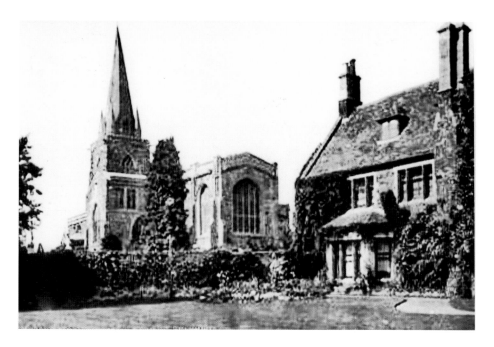

Adderbury: St Mary's Parish Church

Adderbury, 3½ miles to the south of Banbury, was formerly a market town of some importance, although it is now regarded merely as a village. St Mary's church is a cruciform structure, incorporating a nave, aisles, transepts, porches and a west tower. The chancel was rebuilt *c.* 1412, the mason being Richard Winchcombe who also built the Divinity School at Oxford. A monument within the church commemorates the Reverend Dr William Oldys (*c.* 1590–1645), who was shot dead by a Parliamentarian soldier during the Civil War.

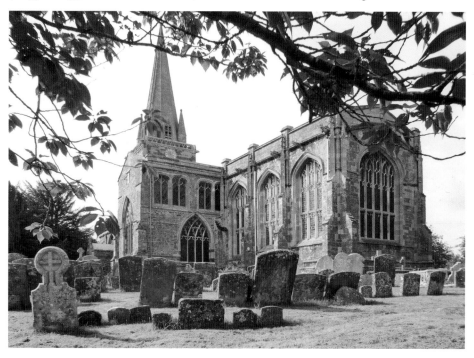

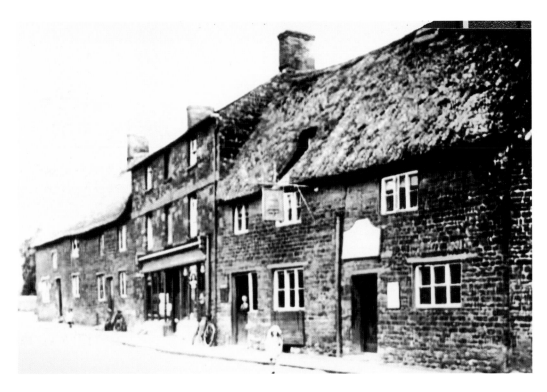

Adderbury: The Bell Inn

The village is divided into Adderbury East and Adderbury West by the Sor Brook, the parish church being in Adderbury East, the largest of the two settlements. The upper view depicts the Bell Inn and other old buildings in the High Street, probably around 1930, while the recent colour view was taken from a different angle in 2012; the inn is still open, although its thatched roof has been replaced. Mill Lane, to the right of the picture, gives access to the parish church.

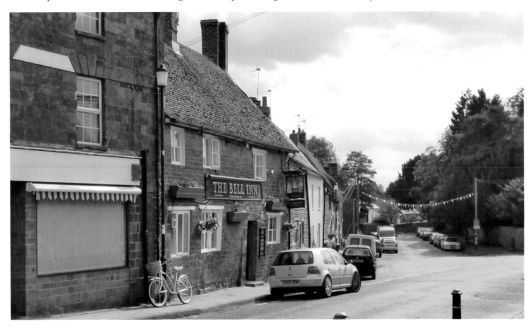

Ascott-under-Wychwood: London Lane

Above: Ascott-under-Wychwood is a Cotswold-style village on the south side of the Evenlode Valley. It contains a Norman church and many attractive old houses, some of which can be seen in this *c.* 1930s view of London Lane; High Street diverges to the right of the picture, while the village school can be glimpsed to the left. *Below*: This recent view, showing the junction of London Lane and High Street in April 2013, reveals that few changes have taken place in this part of the village.

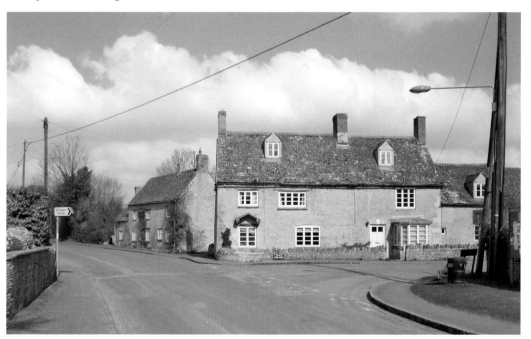

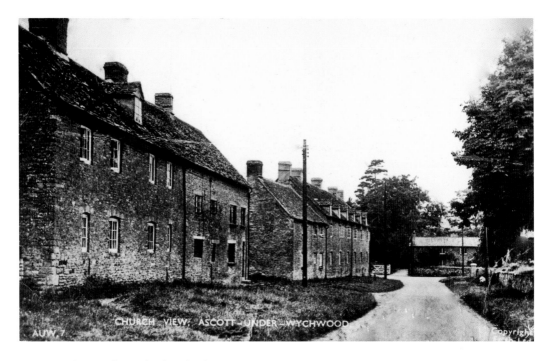

Ascott-under-Wychwood: Church View

Church View is a quiet side street sited immediately to the west of the parish church. It contains two rows of terraced cottages that overlook the churchyard. The upper picture, from a creased and damaged postcard, depicts these Cotswold-stone dwellings prior to refurbishment, whereas the recent photograph, taken in April 2013, shows the same properties in a much better state of repair. At the time of writing, a three-bedroom cottage in Church View is being offered for sale at a price of £499,950.

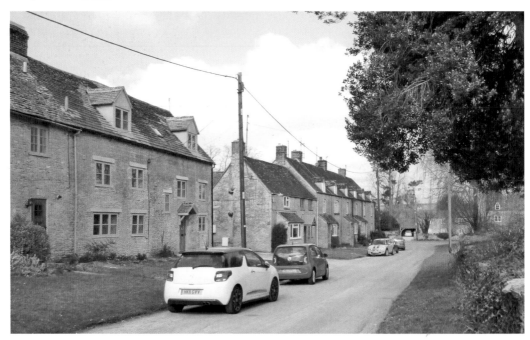

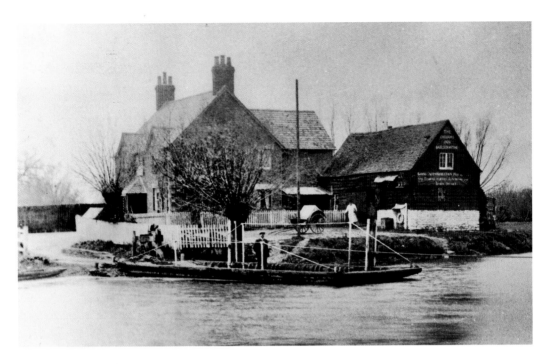

Bablockhythe: The Ferryman Inn

Bablockhythe, some 11 miles 4 chains upstream from Oxford, was once the site of a vehicular ferry, and although this quaint old feature has disappeared, a pedestrian ferry still operates sporadically at the Ferryman Inn. The upper picture provides a glimpse of the ferry around 1908, with the inn (then called The Chequers) visible in the background. The recent colour photograph shows the large modern pub that now occupies the site.

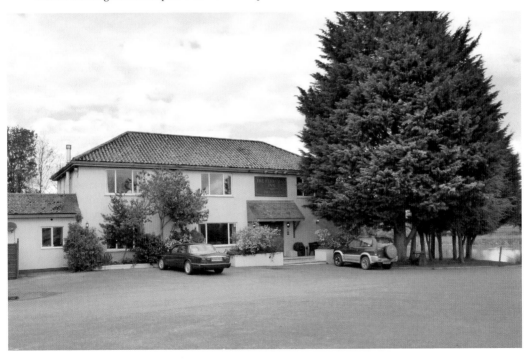

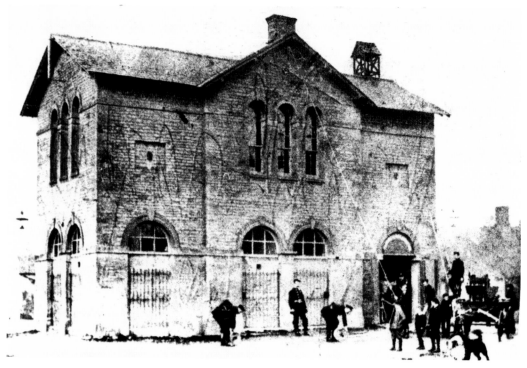

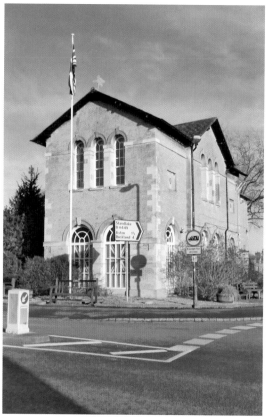

Bampton: The Town Hall & Market Square

The Domesday Survey of 1086 reveals that Bampton was a royal manor, and one of the largest settlements in the area, its population of around 500 being twice that of neighbouring Witney. *Above*: Situated in the Market Square, at the junction of Bridge Street, Cheapside and High Street, the substantial, Italianate Town Hall, erected *c.* 1838, stands in the centre of Bampton. It was designed by George Wilkinson (1813–90) of Witney, a prolific local architect who subsequently became architect to the Poor Law Commissioners. In this capacity he designed numerous workhouses throughout England, Ireland and Wales, together with several Irish railway stations, including those at Sligo and Mullingar on the Midland Great Western Railway. Bampton fire station was situated on the ground floor of the Town Hall, and the volunteer firemen and their hand-pumped engine can be seen in this Victorian photograph. *Left*: The Town Hall in January 2013.

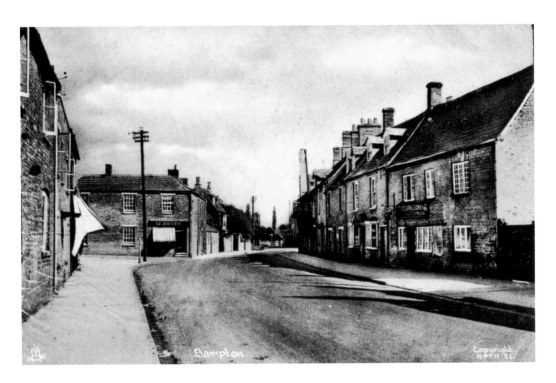

Bampton: The High Street

Two views of Bampton High Street, the upper view being from a postcard of *c.* 1920, while the colour photograph was taken in January 2013. The building that can be seen to the right in the upper picture was occupied by Clark & Son, cobblers. The New Inn was about four doors further along the street, and its inn sign is just about visible beneath the very tall chimney. This pub has now been renamed The Morris Clown, reflecting Bampton's links with traditional morris dancing.

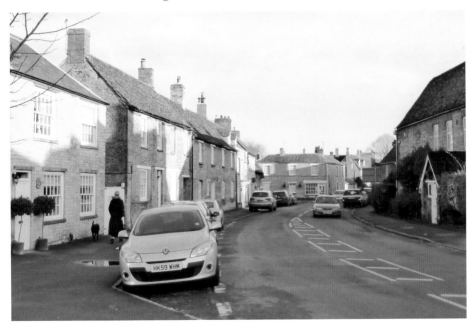

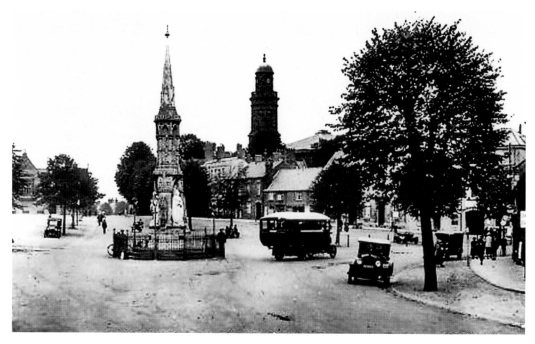

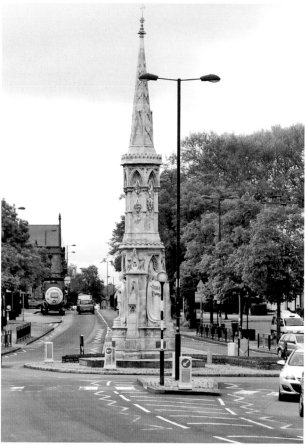

Banbury: The Famous Cross
Banbury, the second largest town in Oxfordshire with a population of approximately 45,000, once boasted several interesting old buildings, including a castle and a medieval parish church, but most of these historic structures were demolished during the seventeenth and eighteenth centuries. The famous Banbury Cross was erected in 1859 in imitation of an original medieval cross that had been destroyed in 1612. The upper picture is a postcard view of c. 1912, while the lower photograph shows the famous cross in 2013. The old church was blown up with gunpowder in 1790 to avoid the expense of restoring it. Its replacement is a classical structure with a cylindrical tower that can be seen to the right of the cross.

Banbury: Parson Street

Despite the loss of its medieval church and castle, Banbury still contains a number of picturesque old buildings, one of these being the sixteenth-century Reindeer Inn, which can be seen on the extreme left in this *c.* 1930 postcard view of Parson Street. The colour photograph, taken by Robbie Robinson in November 2012, reveals that this historic structure has remained intact. The wooden gates at the entrance are dated 1570, while a gabled room at the rear of the inn is dated 1624.

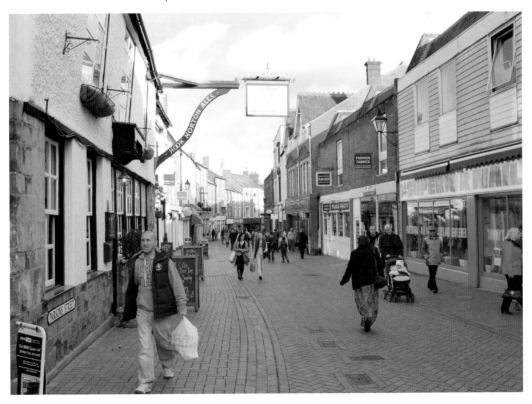

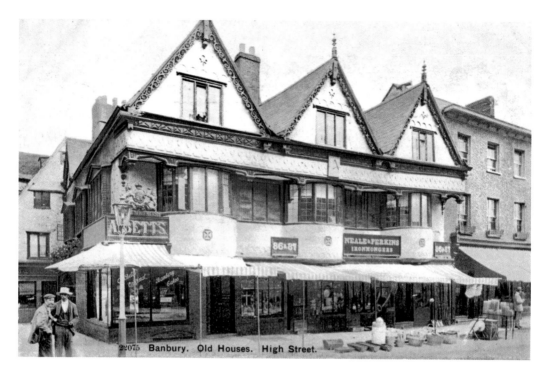

22075 Banbury. Old Houses. High Street.

Banbury: The High Street

Above: An Edwardian colour-tinted postcard showing Nos 85–87 High Street, which was originally a single property. The gables have finials and ornamental bargeboards, but the most noteworthy feature of the building is its elaborate pargetting. *Below*: A sepia postcard view of the north-eastern end of Banbury High Street, with Nos 85–87 visible to the left; this part of the street is now a pedestrianised precinct.

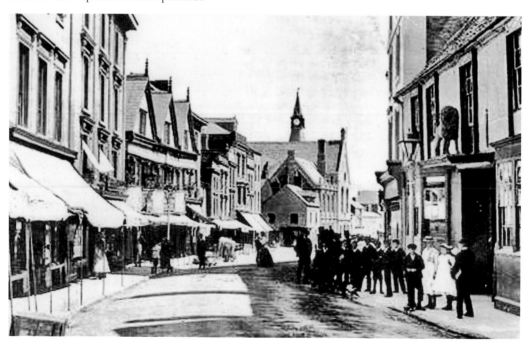

Bicester: Sheep Street

Now a rapidly expanding urban centre with a population of around 30,000, Bicester was, for many years, regarded as an old-fashioned market town – although Joanna Cannan was clearly being over-harsh when she dismissed it as 'a dull little town, set in flat, damp country'! She did, however, concede that Bicester was a famous fox-hunting centre, its very name seeming 'to stand for all that was most dashing and desirable'. *Above*: A *c.* 1920s view of Sheep Street. *Below*: Sheep Street in April 2013.

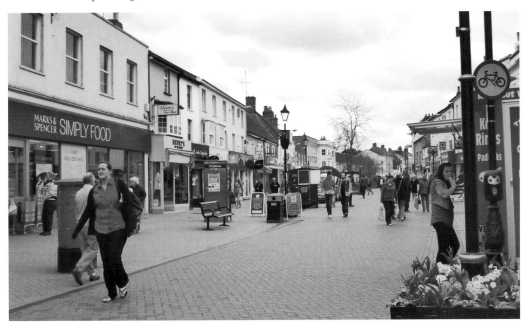

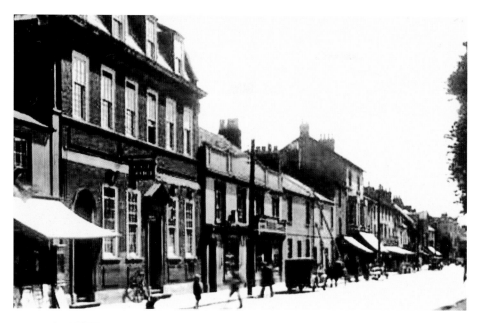

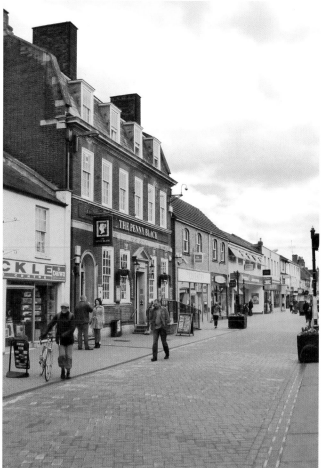

Bicester: Sheep Street & The Old Post Office
Above: A further view of Sheep Street, now a pedestrian precinct, photographed from a position somewhat further to the north, probably during the 1930s. The tall, red-brick building that can be seen to the left of the picture was the post office. *Left*: This recent photograph was taken from a similar vantage point in April 2013; the former post office is now a pub with an appropriate name – The Penny Black!

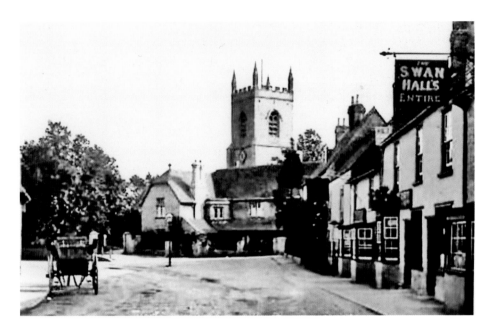

Bicester: Church Street

Church Street forms part of a thoroughfare running west-north-westwards from The Causeway which, in turn, forms a link with Market Square. These two views show Church Street in the early twentieth century and in April 2013. Both pictures are looking east towards the Market Square, with the tower of St Eadburg's church visible in the background. The building that can be seen in front of the church is the Old Vicarage, parts of which date back to the fifteenth century.

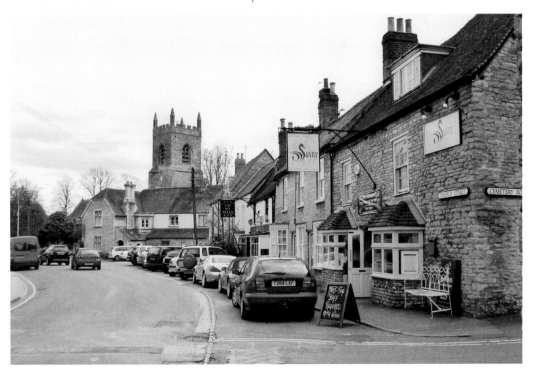

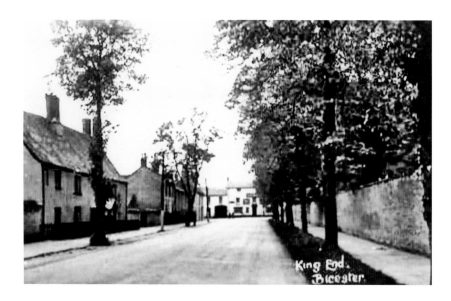

Bicester: King's End

At its western end, Church Street forms an end-on junction with King's End, which is shown in these two illustrations; the sepia postcard dates from around 1920, while the colour photograph was taken in April 2013. The Cotswold-style building that can be seen to the left is Home Farmhouse, a seventeenth-century structure with wooden lintels and an old timber-built porch with flanking settles. The brick chimneys have been rebuilt, but two diagonal stacks (which may be original features) can still be seen.

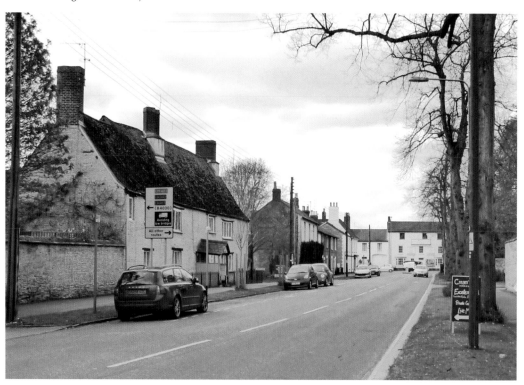

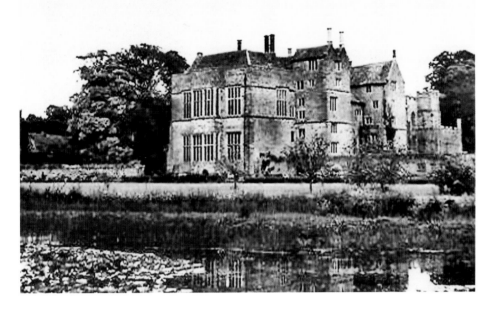

Broughton Castle

Broughton Castle, near Banbury, the ancestral home of the Fiennes family, originated in the fourteenth century, when Sir John de Broughton obtained a licence to crenellate his manor house. The castle subsequently passed by marriage to Sir William Fiennes, whose descendants transformed the building into an Elizabethan mansion. Shorn of its defences, Broughton was unable to withstand a siege, and the castle was captured by the Royalists at the start of the Civil War. The photographs show this moated castle around 1920 (*above*) and in 2013 (*below*).

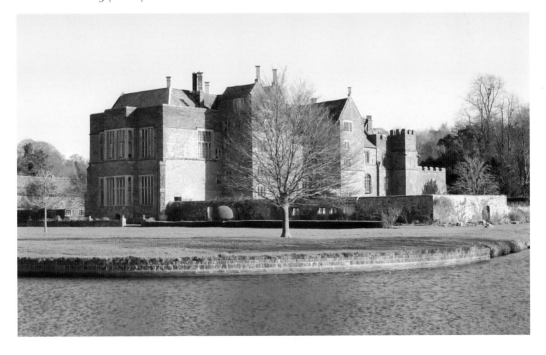

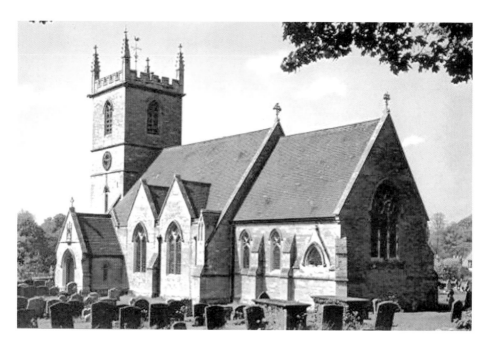

Bladon: Sir Winston's Final Resting Place

Winston Churchill was born in Blenheim Palace on 30 November 1874 and died in London on 24 January 1965, his body being conveyed from Waterloo to Handborough station by special train on 30 January. From Handborough, the dead statesman was taken by hearse to Bladon for a private burial in St Martin's churchyard, beside the grave of his father, Lord Randolph. The upper view shows the church around 1912, while the lower photograph was taken a century later, in January 2013.

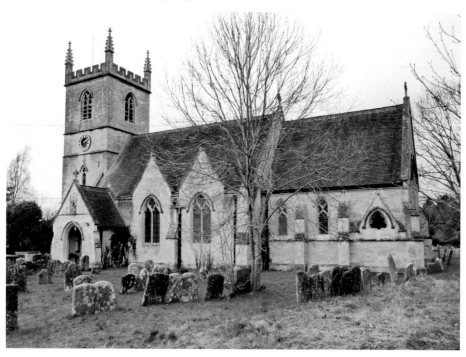

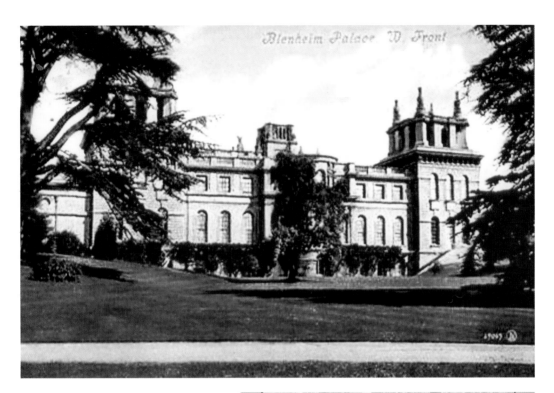

Blenheim Palace: The West Front & The Woodstock Gateway

Now regarded as one of Oxfordshire's leading tourist attractions, Blenheim Palace and its surrounding estate was conferred on John Churchill, the first Duke of Marlborough (1650–1722), as a reward for his stunning victory over the French at the Battle of Blenheim in 1704. This huge Baroque building was designed by John Vanbrugh (1664–1726) and Nicholas Hawksmoor (1661–1736), and completed in the 1720s. The palace is a rectangular structure with square towers at each corner, the main block being flanked by two outlying courts, one of which is known as the Kitchen Court, while the other is the Stable Court. The upper view, from an Edwardian colour postcard, shows the West Front of the palace, while the photograph to the right shows one of the somewhat forbidding gateways to the Kitchen Court.

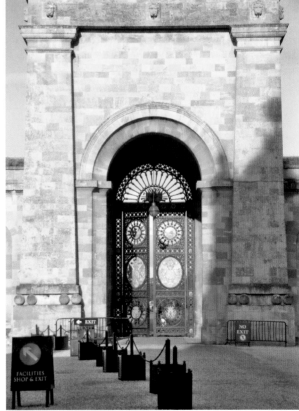

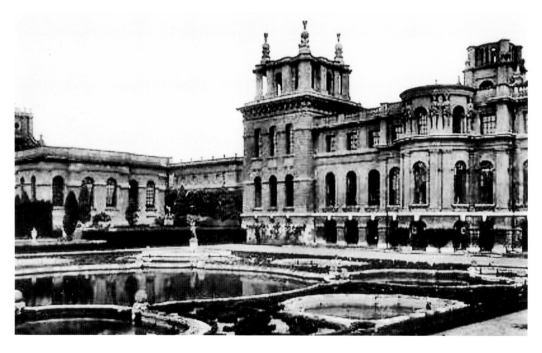

Blenheim Palace: The West Front

These two pictures provide further views of the West Front, the upper view being from an old postcard of *c.* 1925, while the lower photograph was taken in March 2007. The Stable Court, which can be seen to the left in the upper picture, is linked to the main block by a connecting arcade. Note the female figures known as caryatids, which can be seen between the upper windows of the projecting centre bay.

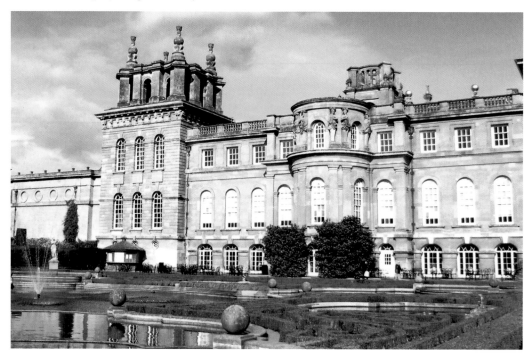

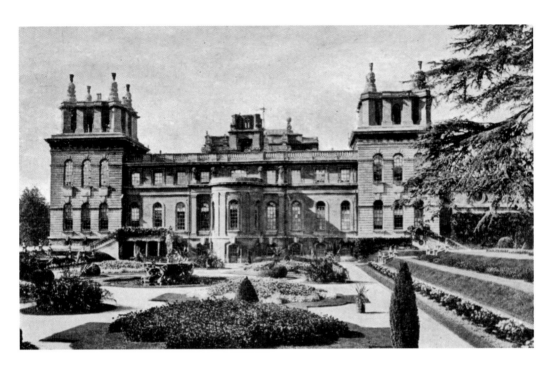

Blenheim Palace: The East Front

Above: An old postcard view of the East Front, which is similar to the West Front, although the curved central bay does not extend the full height of the building. *Below*: A view of the palace from the south-east. The massive corner towers resemble the projecting bastions of a fortress, which is highly appropriate when one considers that the building was intended to commemorate a great military victory; the finials on top of the towers represent cannon balls.

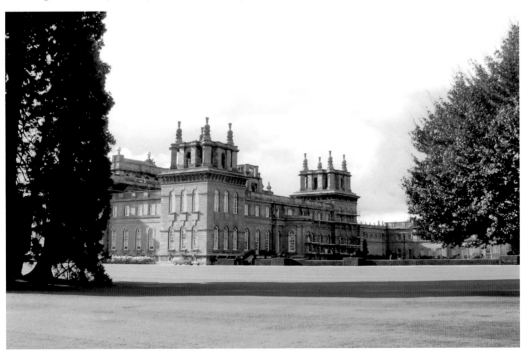

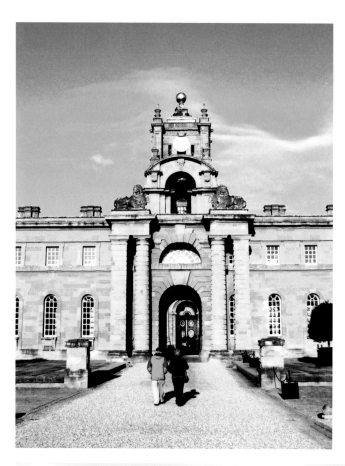

**Blenheim Palace:
The Kitchen Court & the
Water Gardens**
Left: A detailed view showing
the west gateway of the
Kitchen Court, which is in
the form of a triumphal arch
with Doric columns and an
open pediment. *Below*: The
Water Terrace Gardens, on
the west side of the palace,
were laid-out during the
1920s by the celebrated
French garden designer
Achille Duchêne (1866–1947).
He also designed the East
Formal Garden, which can be
seen on p. 23.

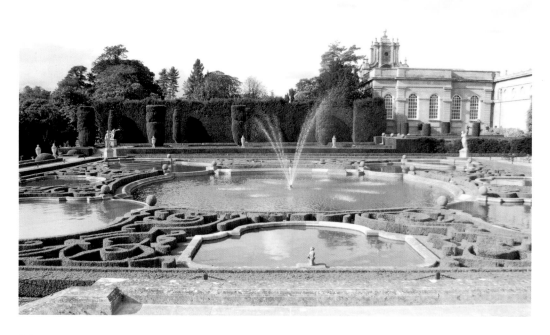

Broadwell: The Church of St Peter & St Paul

Broadwell, 8 miles south-west of Witney, is a quiet place, with Cotswold-stone cottages and an impressive parish church. The manor house was burned down long ago, leaving just two tall gate pillars beside the village street. The parish church, dedicated to St Peter and St Paul, is mainly Norman, although the transepts and impressive spire were added in the thirteenth century. Broadwell gave its name to a Second World War aerodrome that was opened in 1943, and used primarily by Dakotas of Nos 512 and 575 Squadrons, which participated in the D-Day invasion by conveying the 8th and 9th Parachute Regiments and the 1st Battalion Royal Ulster Rifles to Normandy – the Ulsters being carried in Horsa gliders. The airfield was closed after the war, although the abandoned runways and other wartime infrastructure can still be seen around 1½ miles to the north of the village.

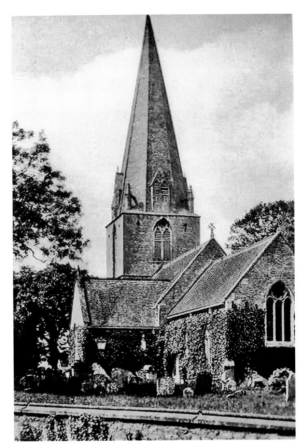

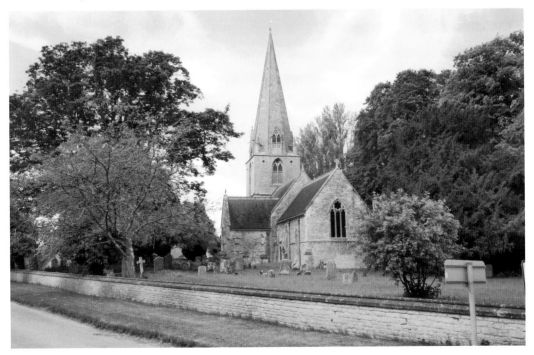

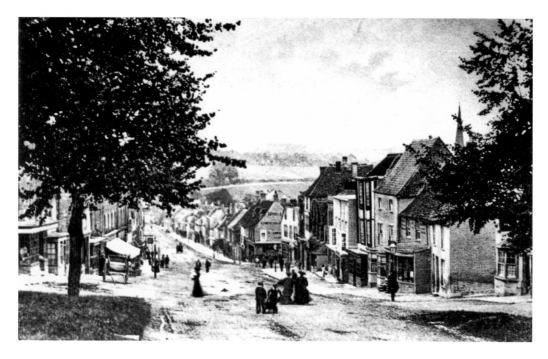

Burford: The High Street

Burford is one of the most attractive small towns in Oxfordshire. It consists chiefly of one long street, which climbs steeply from the Windrush Bridge, with side streets such as Sheep Street and Witney Street extending westwards and eastwards respectively. There are many old buildings, most of these being constructed of Cotswold stone. The upper view, from an Edwardian postcard, is looking down the High Street towards the river, while the colour photograph was taken in January 2013.

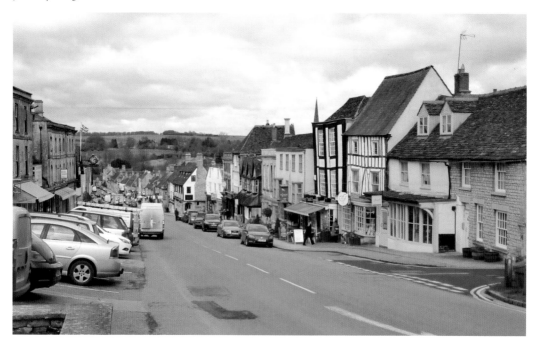

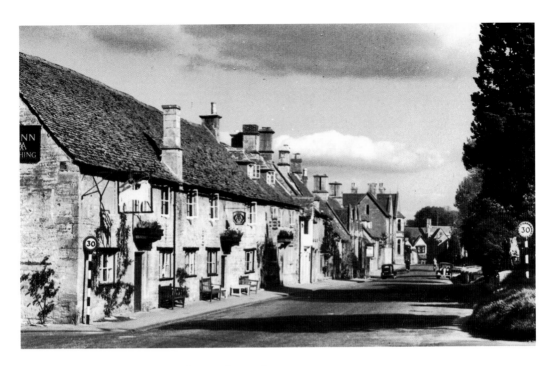

Burford: Sheep Street & The Lamb Hotel

The upper photograph provides a general view of Sheep Street, looking east towards the High Street, *c.* 1950. The Lamb Hotel, which can be seen to the left, dates back to the fifteenth century, and portions of the medieval fabric can be detected in the west façade, which flanks Priory Lane. The recent colour view was taken from a slightly different angle in January 2013. The building, which incorporates several earlier properties, became an inn during the eighteenth century, when Burford was an important coaching town.

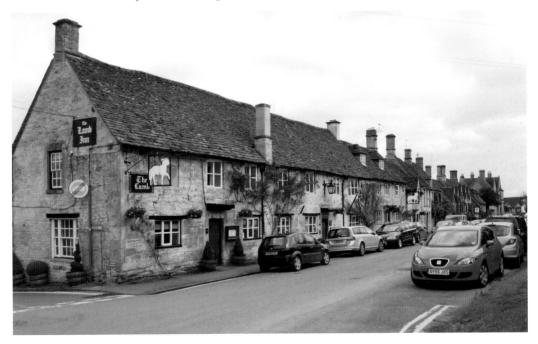

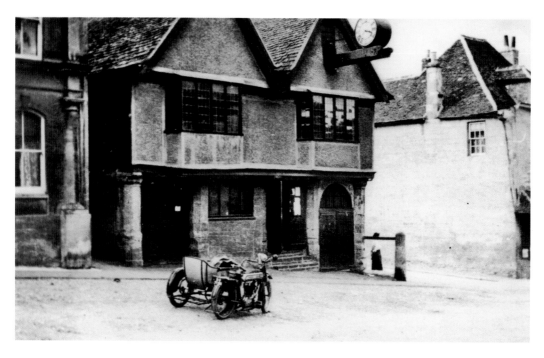

Burford: The Tolsey

Above: The 'Tolsey', on the west side of High Street, is thought to be of sixteenth-century origin. It was used as a courthouse and market hall, and now houses a local history museum. This quaint old structure is of timber-framed construction, the upper floor being raised upon stone pillars to form a small loggia. The right-hand gable incorporates a pair of projecting beams, which support a bell and a clock. *Below*: The Tolsey in January 2013.

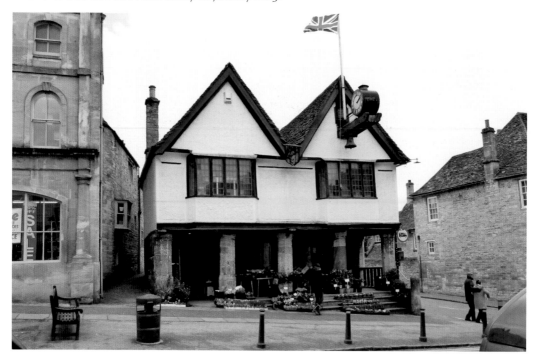

Burford: St John the Baptist Church & The Leveller's Mutiny

The Parliamentarian soldiers who won the Civil War regarded themselves 'no mere mercenary army' but as citizens-in-arms, who had fought for 'the just rights and liberties' of the people. Some more radical soldiers even demanded the right to vote, these early democrats being known as the 'Levellers'. In May 1649, Colonel Scrope's Regiment mutinied in Salisbury and marched towards Burford where, joined by other Leveller activists, they occupied the town. General Fairfax acted quickly to stamp out the mutiny, and around 400 mutineers soon found themselves locked up in Burford church. On 19 May 1649, Cornet Thompson, Corporal Perkins and Private John Church were put against the churchyard wall and shot, their fellow mutineers being forced to witness the executions from the church roof. The remaining mutineers were then sent home – having gained a place in history as pioneers of the working class movement. *Above*: A photograph of the church, probably dating from the 1930s. *Below*: A plaque on the church wall commemorates the three Leveller soldiers shot for mutiny in 1649.

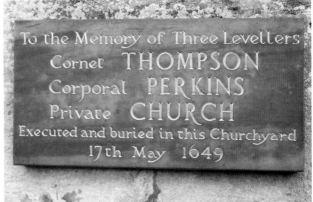

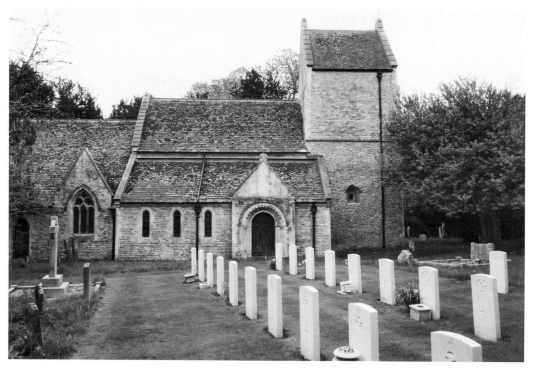

Caversfield: St Lawrence's Church

Although it is now virtually a suburb of Bicester, Caversfield was, historically, an entirely separate village, with its own church and manor house. The church, dedicated to St Lawrence, incorporates a nave, chancel, tower and aisles – the latter being Victorian additions on the site of the medieval aisles, which were demolished in the eighteenth century. The tower is of particular interest, in that its lower storey is of Anglo-Saxon origin and may date back to the tenth century; the tiny north and south windows are simple, double-splayed openings. The saddleback roof dates from a remodelling of the church that was carried out in the thirteenth century. The upper photograph, taken in 2013, shows the church from the south – the neat rows of Commonwealth war graves visible in the foreground being a reminder that Bicester was once the site of an important Bomber Command aerodrome. The earlier view provides further details of the historic tower.

Chipping Norton

Chipping Norton is situated in an elevated position about 700 feet above mean sea level, and in winter it can be a surprisingly bleak place. The name of the town means 'The North Market' ('Chipping' being an Old English word for market). The upper photograph shows houses on the eastern side of High Street, *c.* 1950, while the recent view provides a glimpse of Market Street, which flanks the western side of a spacious marketing area.

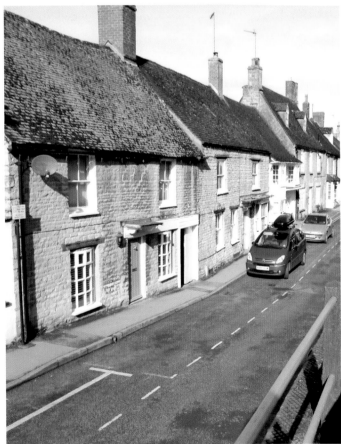

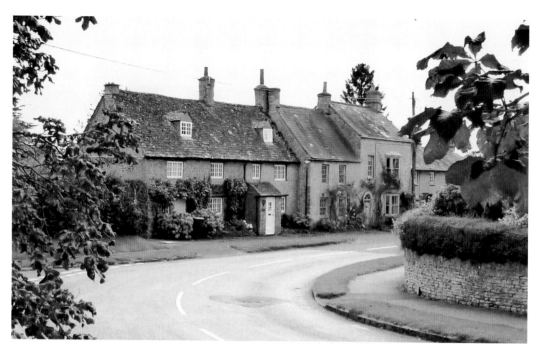

Churchill

Situated about 3 miles south-west of Chipping Norton, Churchill was the birthplace of Warren Hastings (1732–1818), the first Governor-General of India, and also the birthplace of William Smith (1769–1839), the 'Father of British Geology', who made the first geological maps and introduced many of the names by which we know the various rock strata. The upper picture, taken from All Saints churchyard in 2012, shows cottages in Junction Road, while the lower photograph is looking in the opposite direction towards the church, the cottages that featured in the previous view being visible to the right. Consecrated in 1827, All Saints church replaced an earlier church in Hastings Hill Lane. The new church was paid for by James Langston, the local squire, and it boasts a spacious interior with a hammer-beam roof copied from that at Christ Church College, Oxford.

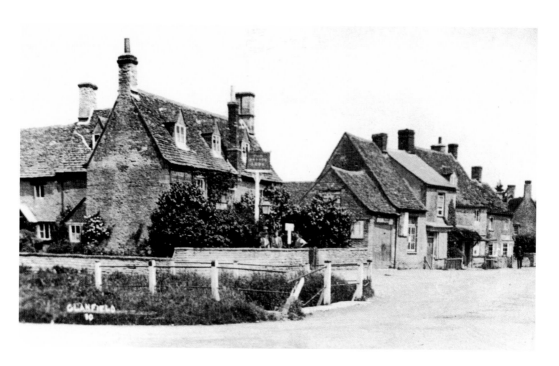

Clanfield: The Clanfield Tavern

Clanfield, 8 miles south-west of Witney, is one of a group of pleasant, Cotswold-style villages that are sited amid the dead-flat water meadows of the Upper Thames Valley. *Above*: The Clanfield Tavern, on the corner of Main Street and Bampton Road, is an eighteenth-century building which was formerly known as The Mason's Arms; the bridge in the foreground crosses a small stream that flows through the village alongside Main Street. *Below*: A recent view, taken in January 2013.

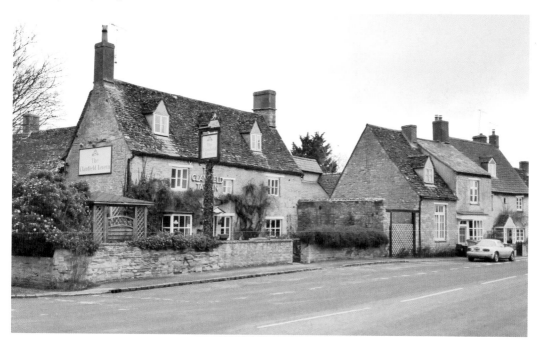

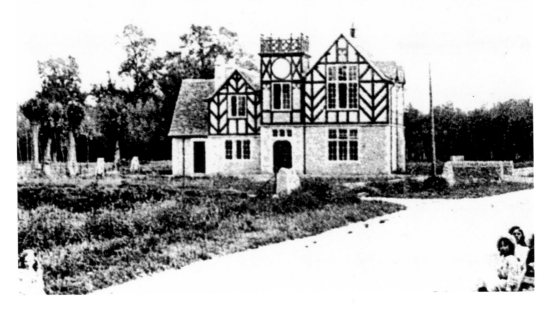

Clanfield: The Carter Institute

This curious building was built as a village reading room in 1906, a £500 bequest having been provided by Amelia Carter, a local benefactress who had died in the previous year. It is a vernacular revival-style structure, with a squat tower and, as shown in the upper view, the first floor was originally timber-framed. The building, containing a large hall, a kitchen, a billiard room and other facilities, was designed by Alfred Mardon Mowbray (1849–1915) of Oxford; the builder was Joseph Bowley of Lechlade.

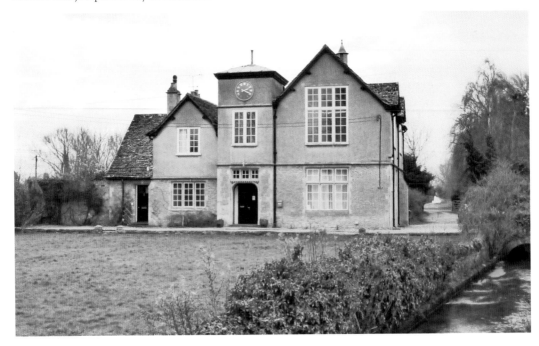

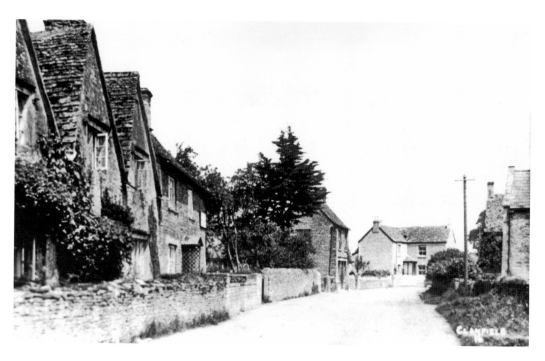

Clanfield: Old Cottages in Bampton Road

These two views are looking eastwards along Bampton Road, the sepia photograph having been taken during the 1930s, while the colour photograph was taken in 2013. The house with the three prominent gables that can be seen on the left-hand side of the road is thought to date from around 1600, although it has been extended and modified at various times, and was, at one time, divided into two separate cottages. It is now known as Tudor House.

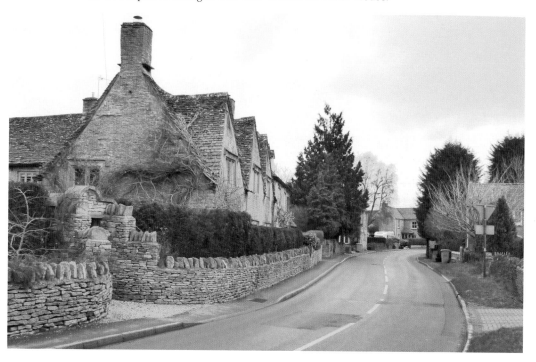

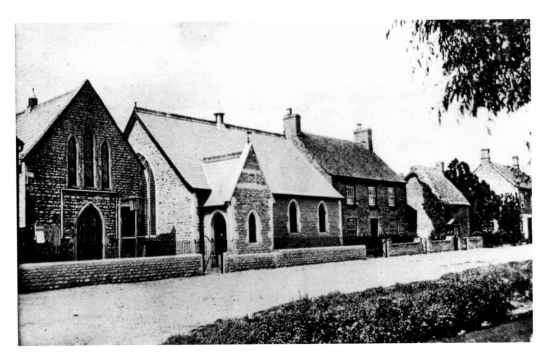

Clanfield: The Former Wesleyan Methodist Chapel

Although rural Oxfordshire was traditionally an Anglican stronghold, there were pockets of Nonconformity in various places. Clanfield's Wesleyan chapel was opened in 1861 and extended in 1909 – the original chapel being adapted for use as a meeting room and Sunday school. The upper picture provides a glimpse of the chapel during the early twentieth century; the newly-built extension can be seen to the right. The recent view shows the building being converted into a residential property.

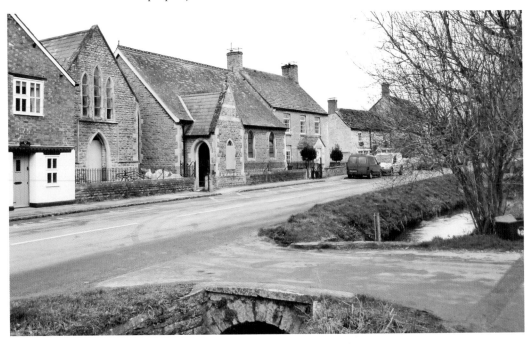

Clifton Hampden

Prior to local government reorganisation in 1974, the Thames had formed Oxfordshire's southern boundary for a distance of 71 miles; the great river being, in some respects, a sort of 'subsitute coastline' for this inland county! Clifton Hampden, about 8 miles to the south of Oxford, is an archetypal Thameside village. These Edwardian postcard views show old thatched cottages near the river, and the famous Barley Mow Inn, which features in Jerome K. Jerome's well-known book *Three Men in a Boat.*

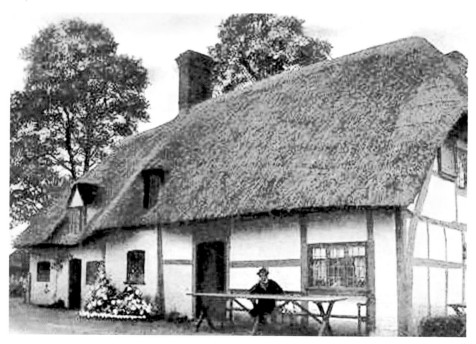

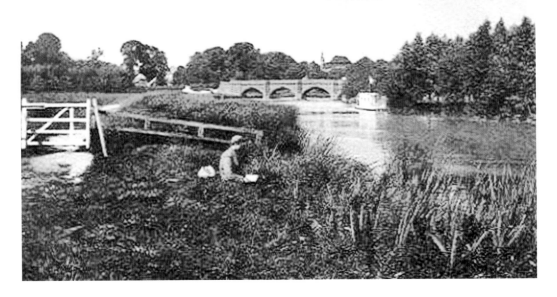

Clifton Hampden

Clifton Hampden bridge was built in 1864 to replace a ferry crossing, the architect being Sir George Gilbert Scott (1811–78). The bridge is of brick construction, with six ribbed 'Tudor Gothic'-style arches; it was originally a toll bridge, and the old toll-house can still be seen on the north bank. The upper view is a colour-tinted postcard showing the bridge around 1912, while the recent colour photograph was taken by Martin Loader; the ribbed arches can be clearly seen.

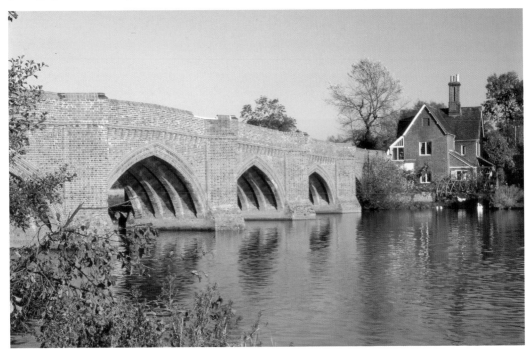

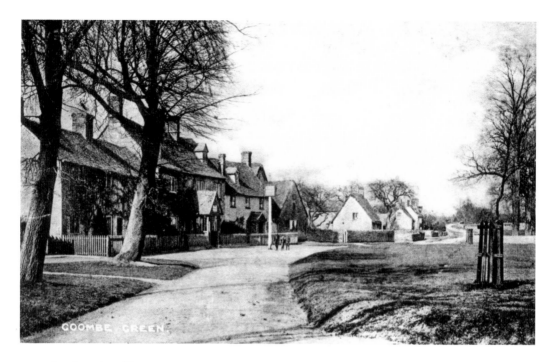

Combe: The Village Green

Occupying a plateau on the east side of the Evenlode Valley, Combe is an attractive village, with stone-built houses clustered around a spacious green. The upper view, from a postcard sent in May 1907, shows the Cock Inn and other buildings on the west side of the green, while the colour photograph was taken from a similar vantage point in April 2013. *Gardner's Directory of the County of Oxford* reveals that, in 1852, Combe had three pubs, but the Cock is the only survivor.

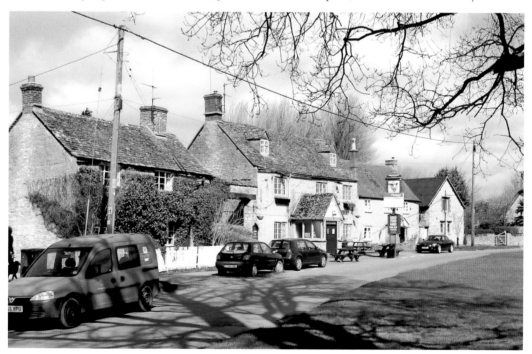

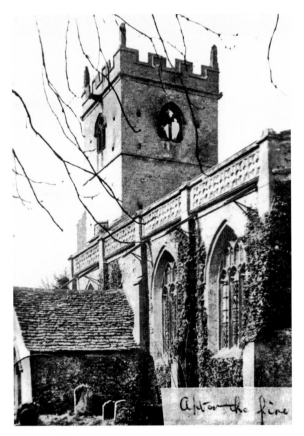

Combe: The Church of St Laurence
The church was rebuilt by the monks of Eynsham Abbey around 1400 to replace an earlier place of worship which, according to a persistent (but entirely conjectural) local tradition, may have been on a different site near the River Evenlode. Although the church is a relatively simple structure consisting of a nave, chancel and west tower, it boasts two porches – the south porch having been adapted for use as a vestry in 1937. The upper view, captioned 'after the fire', was taken in 1918 after fire had damaged the tower, the bells and the church clock. Repairs were completed in the 1920s, but the clock was not replaced until 1948 (the old clock is now in the History of Science Museum in Oxford). The lower photograph, taken in April 2013, shows the church from the south.

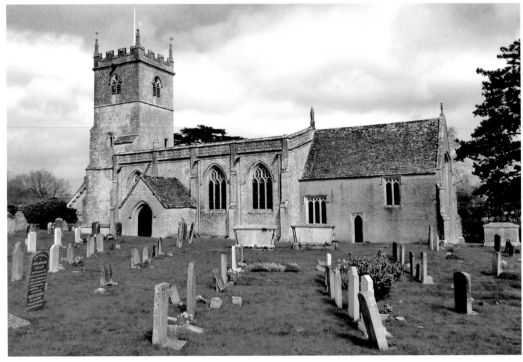

Cornwell

Cornwell is situated in an elevated position, about 3 miles to the west of Chipping Norton. It contains a church, a manor house and many picturesque old houses. The village was rebuilt during the 1930s by the architect Sir Bertram Clough Williams-Ellis (1883–1978), the designer of Portmeirion in North Wales and, as might be expected, some of its buildings are of mildly eccentric appearance, one of the strangest being the former village hall (originally a school but now the estate office), which boasts a curious tower.
Above: A corner of the village, photographed in November 2012.
Right: An earlier view, possibly dating from the 1930s, showing the village hall.

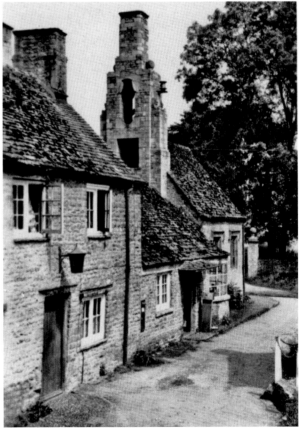

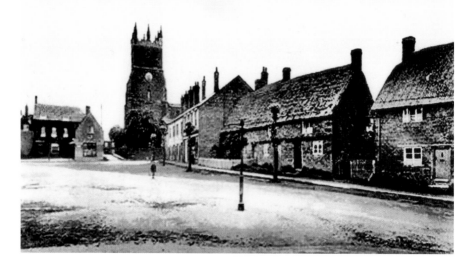

Deddington: The Market Square

The Domesday Book suggests that, in 1086, 'Dadintone', a manor of thirty-six hides belonging to Odo, Bishop of Bayeaux, was one of the largest and most prosperous settlements in the area, with a population of about 500. A castle was constructed after the Norman Conquest, although only the earthworks now remain. The upper picture shows the north end of Deddington's Market Place, around 1912, while the colour view was taken a century later; the church features prominently in the background.

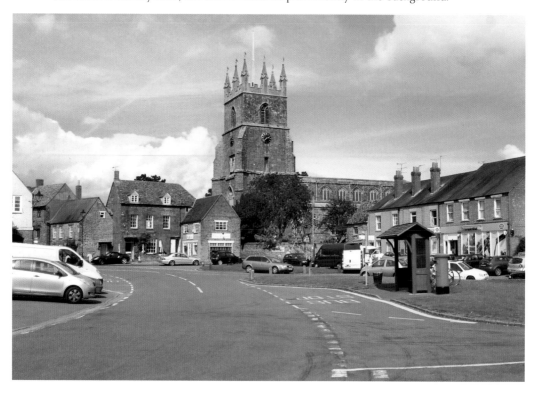

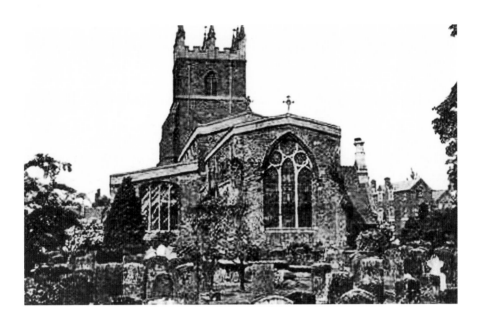

Deddington: The Church of St Peter & St Paul

Two views of Deddington's impressive parish church; the upper view dates from around 1920, while the colour view was taken in 2012. The church, dedicated to St Peter and St Paul, incorporates a nave, aisles, chancel, two porches and a tower. The building was badly damaged when the tower fell down in 1634, and although the tower was rebuilt in 1685, the spire was never replaced. The tower retains figures of St Peter and St Paul, which are said to have been salvaged from the medieval church.

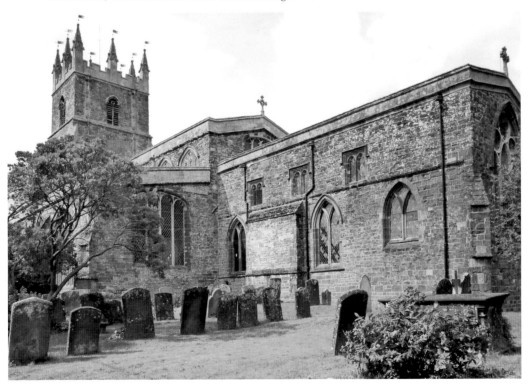

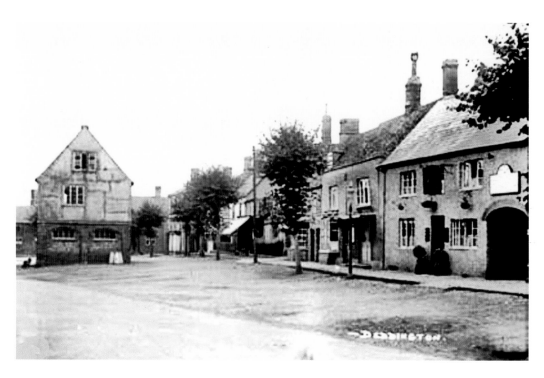

Deddington: Market Place & New Street

The upper view shows the Market Place around 1912. The building on the extreme left is the town hall, which was erected around 1806 to replace an earlier building; the ground-floor arches were, at one time, blocked up, although they have now been opened out. The lower view shows houses in New Street, which was laid out during the Middle Ages in an attempt to expand the town, and eventually became Deddington's main thoroughfare, the northern end being renamed High Street.

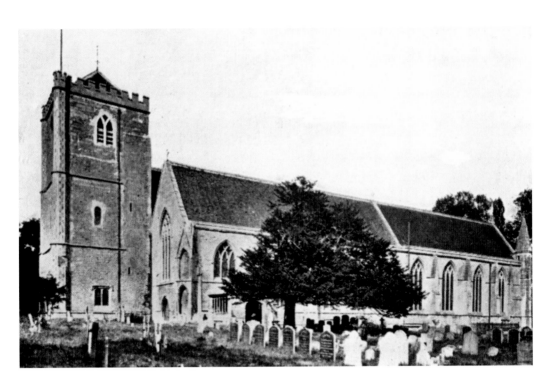

Dorchester-on-Thames

Dorchester, once the ecclesiastical centre of Wessex, is one of the oldest towns in England, with a history that dates back to Roman times. A church was founded here by St Birinus, the first Bishop of Wessex, in the seventh century, and in 1140 it was refounded as an Augustinian abbey. The monastic buildings were dismantled at the time of the Reformation, but the abbey church was retained as a parish church. The sepia view dates from around 1920, and the colour photograph was taken in 2013.

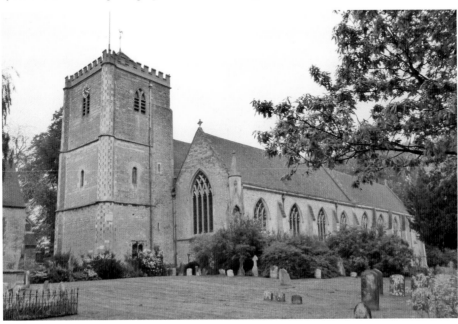

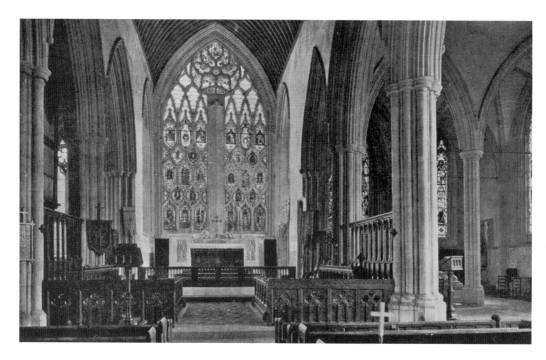

Dorchester-on-Thames

Above: The interior of the abbey church, looking east towards the altar during the 1920s; the east end of the church was extensively reconstructed during the fourteenth century, and the Decorated east window dates from that period. *Below*: A recent photograph of Dorchester High Street, which will be familiar to many television viewers as at least nine episodes of the popular ITV detective series *Midsomer Murders* have been filmed in Dorchester.

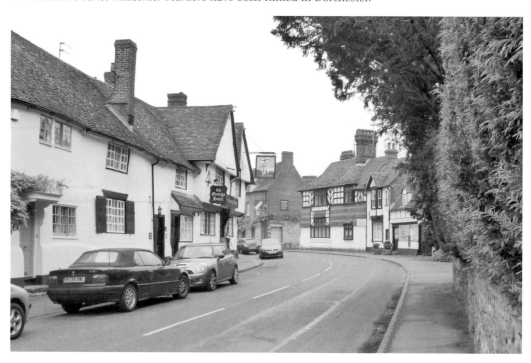

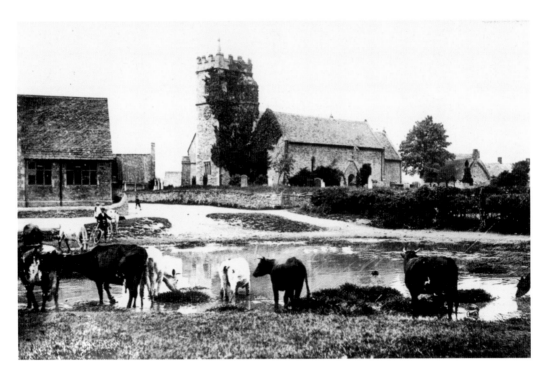

Ducklington: St Bartholomew's Church

Ducklington is a village on the River Windrush, about a mile to the south of Witney, and now virtually joined to it by ribbon development. St Bartholomew's church, which contains evidence of Norman work, is surrounded by Cotswold-stone cottages with thatched roofs, this idyllic scene being enhanced by the presence of a traditional village pond. The National (i.e. Anglican) School, to the left of the church, was built *c.* 1858. The upper view dates from *c.* 1905, and the colour photograph was taken in 2012.

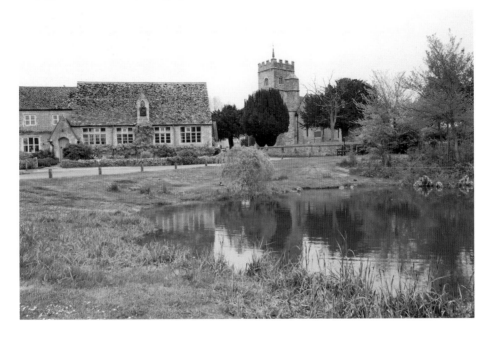

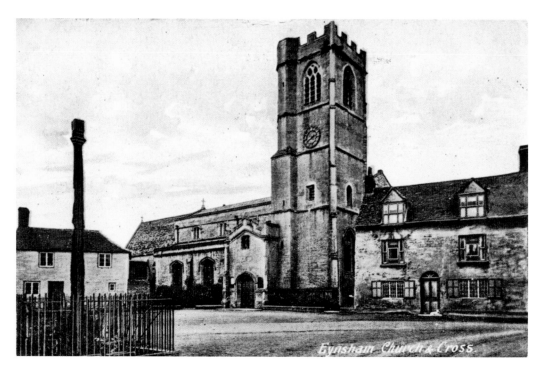

Eynsham: St Leonard's Church & The Square

Eynsham, the only Oxfordshire town on the Upper Thames, was formerly a place of considerable importance, being the site of a major Benedictine abbey which had been founded in 1005, and refounded after the Norman Conquest. *Above*: St Leonard's parish church was sited outside the abbey gates on the south side of The Square, as shown in this postcard view of *c.* 1912. *Below*: A recent view of The Square, looking south-westwards, with the church tower visible on the extreme left.

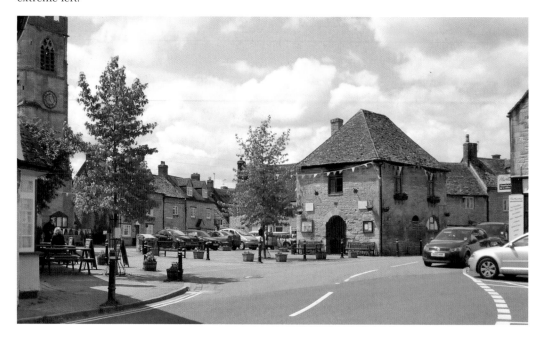

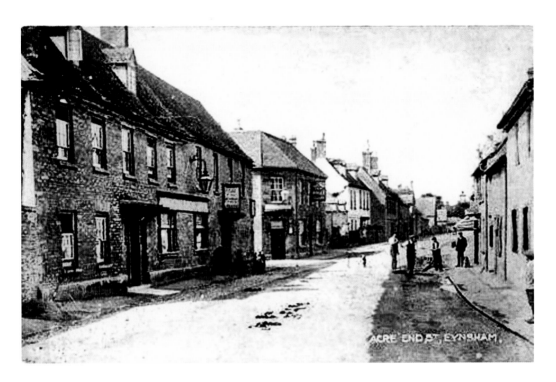

Eynsham: Acre End Street & Mill Street

Above: Acre End Street, which runs westwards from The Square is, in effect, Eynsham's main thoroughfare – its eastern extremity being known as High Street. This *c.* 1912 view is looking west towards Witney. *Below*: Mill Street runs from north to south, forming a junction with Acre End Street at its southern end. This recent photograph, taken in June 2012, is looking south towards Acre End Street.

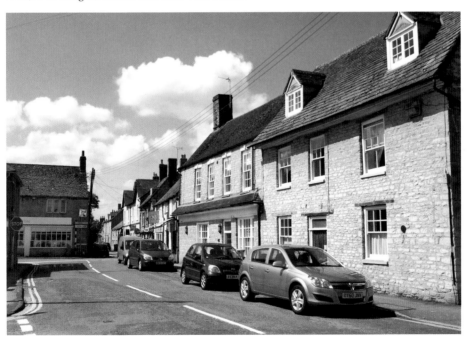

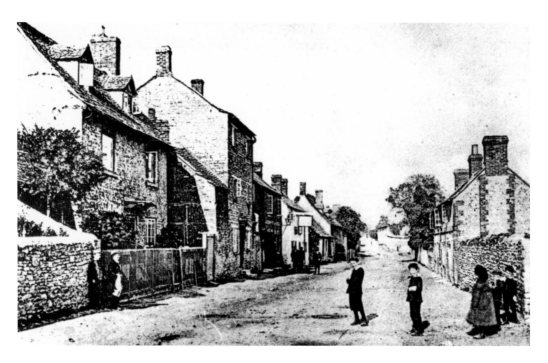

Eynsham: Swan Street

Above: An Edwardian postcard view of Swan Street, looking north towards Newland Street.
Below: A recent photograph, taken from a similar vantage point a century later; pavements have been added, while the tall building on the left has obviously been extended. The Queen's Head pub, to the right of the red-brick cottages, can be identified in the earlier view.

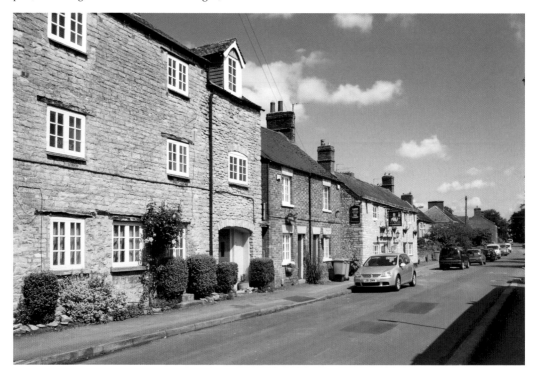

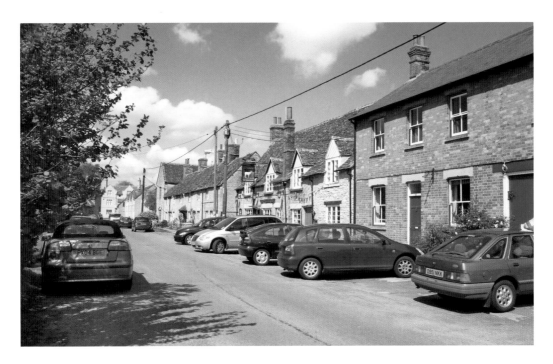

Eynsham: Newland & The Market Hall

Above: Newland Street, which runs eastwards from Mill Street and forms a junction with Swan Street, was laid out by the monks of Eynsham Abbey as part of an urban expansion scheme. *Below:* A detailed study of the seventeenth-century Market Hall, which was built to house a courthouse and John Bartholomew's charity school. It originally featured an open loggia on the ground floor, but this was enclosed during the nineteenth century to create a gaol.

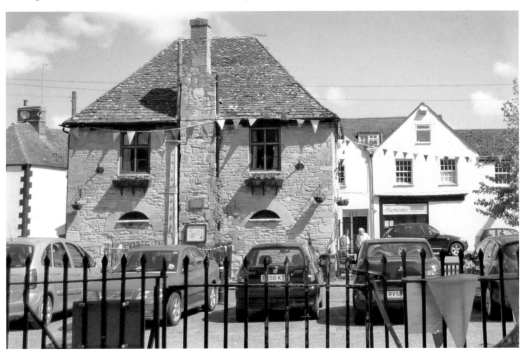

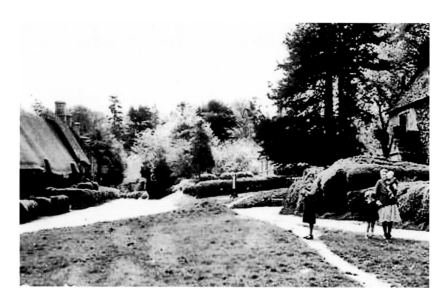

Great Tew

Great Tew is a classic 'chocolate-box' village, that owes much to the work of the Scottish writer and landscape gardener John Claudius Loudon (1783–1843), who managed the estate between 1809 and 1811 and implemented a comprehensive improvement scheme, as a result of which the village acquired its present park-like appearance. The upper view shows Old Road, *c.* 1930, while the lower view is looking eastwards along The Lane towards Old Road in November 2012.

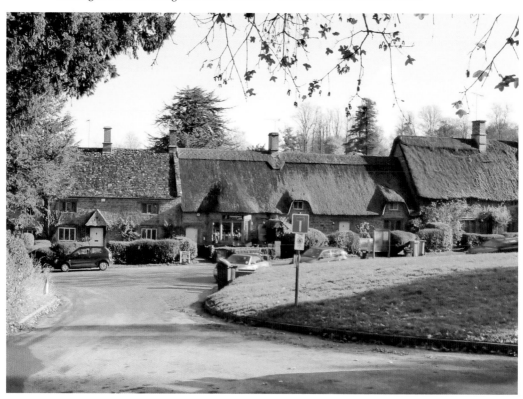

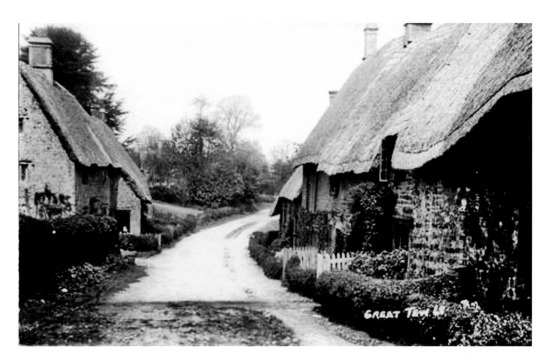

Great Tew

Two views showing cottages at the south end of Old Road. The upper view is looking southwards, probably around 1930, while the lower photograph, taken in 2012, is looking northwards. By the early 1970s, the village had become extremely dilapidated, and there were fears that some of the cottages would be demolished. However, through the efforts of Major Eustace Robb (1899–1985), an army officer and pioneer television producer who acquired the estate in 1962, the derelict properties were gradually restored.

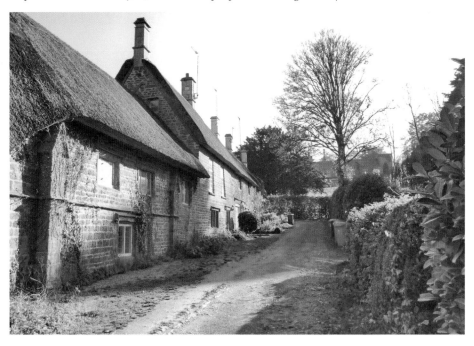

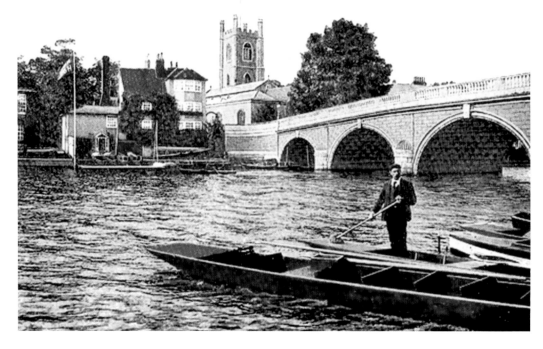

Henley-on-Thames

Henley, an affluent riverside resort, is famous for its annual regatta, which is held in the first week of July. The pictures illustrate Henley Bridge, the upper view being from an Edwardian postcard, while the sepia photograph dates from the 1950s. The present five-arched bridge was designed by William Hayward (1740–82) and completed in 1786. The centre arches are graced by the carved heads of Isis and Thamesis, representing the upper and lower rivers respectively, Isis being a young woman while Thamesis is 'Old Father Thames'.

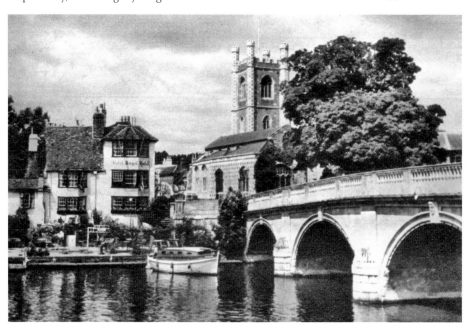

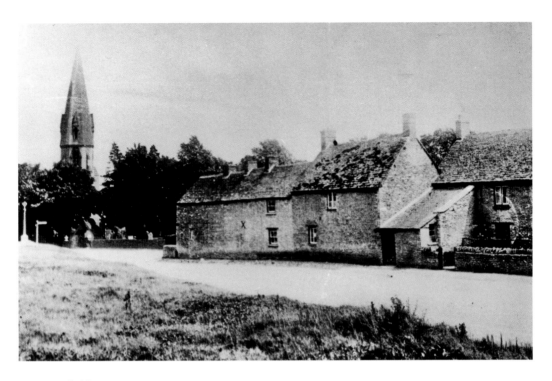

Leafield

Leafield was created by 'assarting', or cutting down trees on a ridge of high land in the depths of Wychwood forest; even today, there is much woodland in the vicinity. The upper picture shows part of the village around 1930, with Leafield's Victorian church visible in the background. In 1913, a wireless station was established near the village, and a cluster of radio masts known as the 'Leafield Poles' remained a prominent local landmark until the closure of the station in the 1980s.

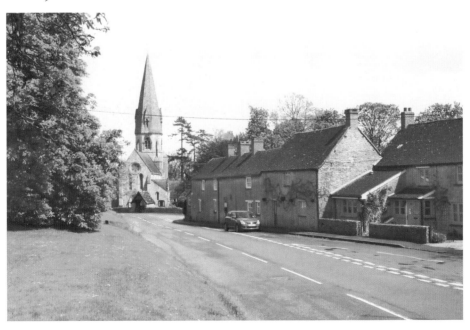

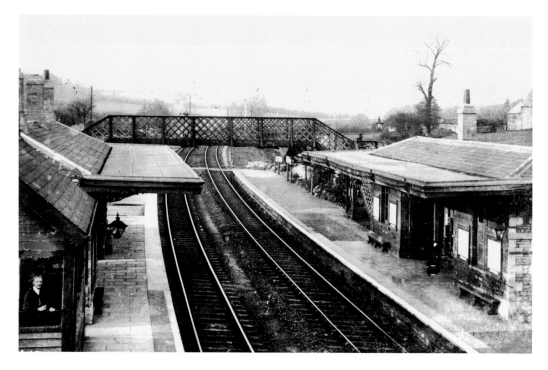

Lower Heyford

Heyford was once a busy village which, according to the 1852 *Gardner's Oxford Directory*, 'commanded an extensive trade' owing to its proximity to the Oxford Canal and the recently-opened Oxford to Banbury railway line. The station, conveniently sited beside the canal wharf, was opened in that same year, and it remains in operation. The upper view shows the station from the road overbridge, while the lower photograph, taken from a position slightly further to the east, shows the station and the canal.

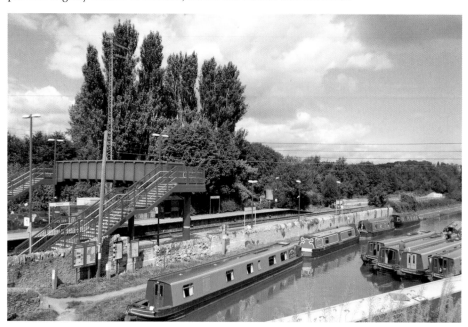

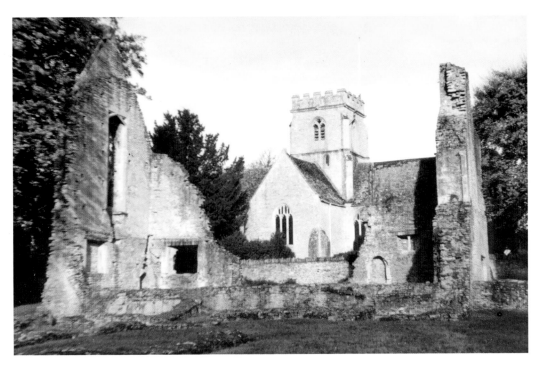

Minster Lovell:
The Lovell Mansion

Minster Lovell passed into the hands of the Lovell family during the reign of Henry I, and the manor house was built by William Lovell in the early fifteenth century. The Lovells remained lords of the manor until 1487, when Francis, the ninth Baron Lovell and favourite of King Richard III, was attainted of high treason after the Battle of Stoke. After serving as an occasional royal residence for several years, the manor house was rented out to suitable tenants such as Alexander Unton, who leased the property in 1536 for a period of twenty-one years. In 1602, the estate was purchased by the Coke family and in the 1740s the then owner, Thomas Coke, dismantled the house. The upper view shows Lord Lovell's private apartments, with St Kenelm's church in the background, while the lower photograph shows the ruined mansion, *c.* 1900, with a farm track running through the site.

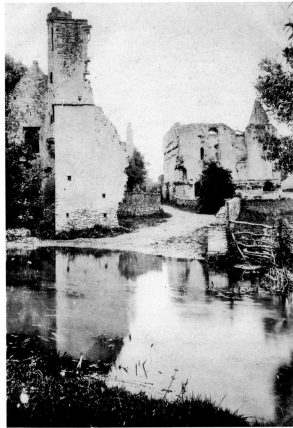

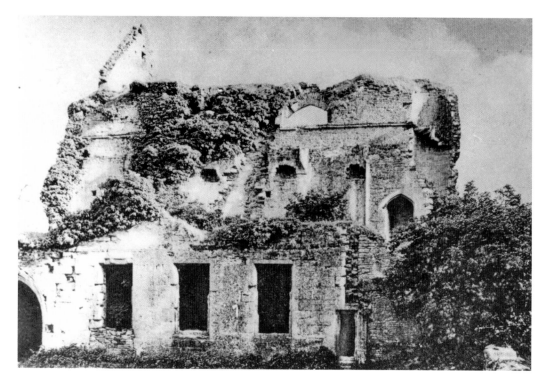

Minster Lovell: Before & After Restoration

In 1935, Minster Lovell manor house was placed in state guardianship as an ancient monument, and in the late 1930s the overgrown site was cleared of debris and generally tidied up. The upper view shows the Great Hall from the north before restoration had taken place, whereas the recent photograph, which is looking towards the ruins from the west, shows the Great Hall and the Lord's private apartments in their present condition.

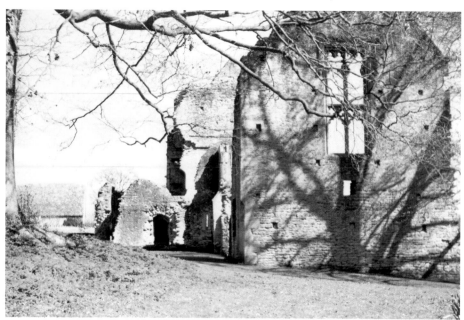

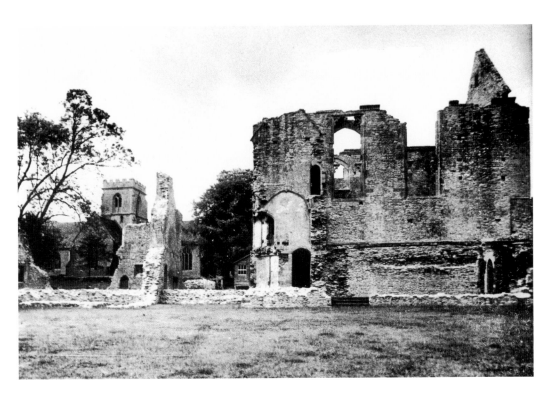

Minster Lovell: The Great Hall

Two photographs of the Great Hall from the south; the upper view probably dates from around 1955, while the colour photograph was taken half a century later. In its fifteenth-century heyday, the Lovell mansion had consisted of two quadrangles or courts, with the Great Hall at its centre. The southern court was the largest of the two, and it extended southwards as far as the River Windrush, the river frontage being protected by a substantial wall, with a tower at the south-western corner.

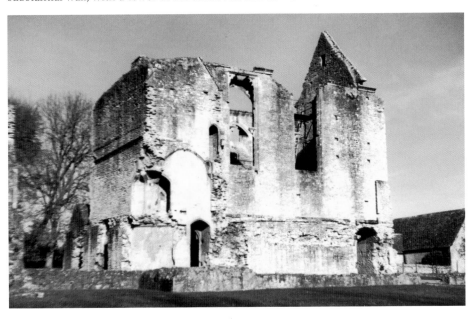

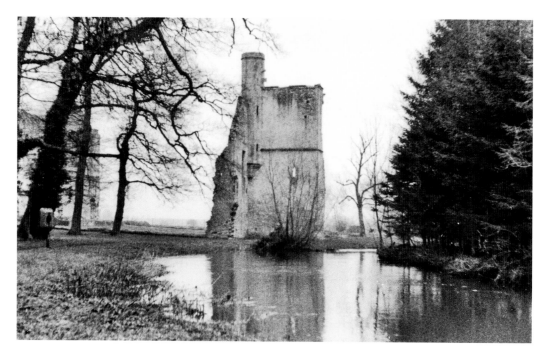

Minster Lovell: The South Tower

Above: The South Tower, which stands within a few feet of the River Windrush, had four levels, the ground floor being merely a toilet or garderobe, while the uppermost storey contained a large chamber with an oriel window. Access to the upper floors was via an octagonal stair turret which continued up to roof level in order to provide access to the battlements. *Below*: A recent view of the South Tower; the remains of the kitchen wing can be seen in the foreground.

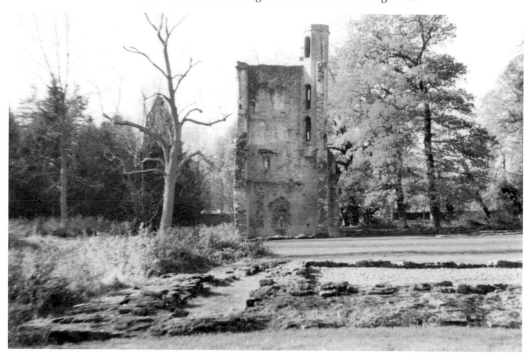

Minster Lovell: Feargus O'Conner & The Charterville Allotments

'Charterville', to the south of old Minster, was created in 1847 by Feargus O'Connor (1796–1855), a leader of the 'Chartist' Movement, which hoped to improve the lot of the working classes through political reform. Drawing on his experiences in Ireland, Feargus's answer to the problems of industrialisation was a retreat to the land, and five model estates were set up, including Charterville. The estate contained seventy-eight Irish-style cottages and a school, which is shown in the upper illustration. The allottees, who were chosen by a lottery, arrived in 1848, but the land was poor, and the 1840s were a period of wet weather and failed harvests. The Chartist tenants drifted away, and by 1851 only three remained. In the fullness of time, the vacant smallholdings were taken over by local people, many of whom specialised in the cultivation of potatoes or other cash crops. *Right:* A Charterville cottage in 2012.

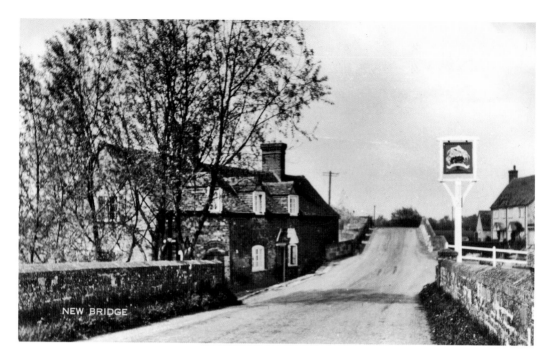

Newbridge: The Maybush

Notwithstanding its name, the medieval bridge at Newbridge is one of the oldest bridges on the Thames; it has six pointed arches, and dates from the fourteenth century. There are two pubs at Newbridge, the Rose Revived being on the north bank while the Maybush Inn is on the south side of the river. The upper view shows the Maybush, *c.* 1930, while the colour view, taken from the north bank in 2012, shows the Maybush and part of the bridge.

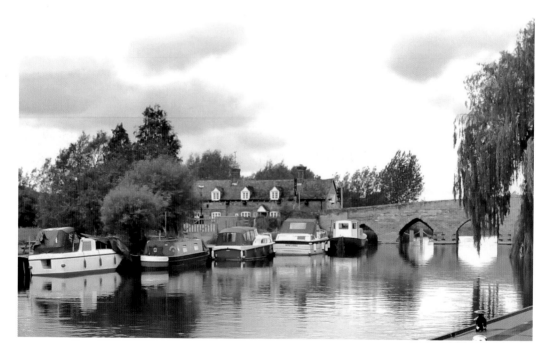

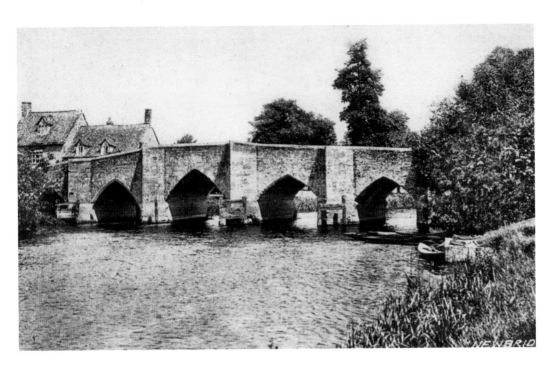

Newbridge: The Rose Revived

Above: This Edwardian postcard shows the ancient bridge from the west, the roof of the Rose Revived being visible to the left. Prior to local government reorganisation in 1974, the Rose Revived had been in Oxfordshire, whereas the Maybush was on the Berkshire side of the river (both are, of course, now in Oxfordshire). *Below*: A recent view of the Rose Revived, taken in May 2013.

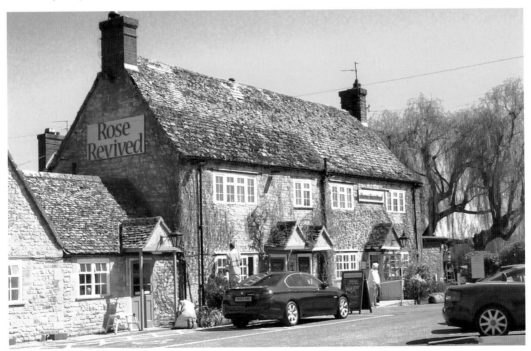

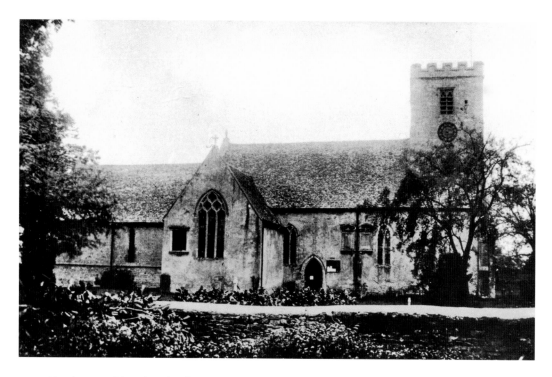

Northmoor: The Church of St Denis

Northmoor is situated amid dead-flat water meadows about 6 miles south-east of Witney. The parish church is a cruciform structure, dating from around 1300, although the embattled west tower dates from the Perpendicular period. The nave has no side aisles, but the most unusual feature of the church is perhaps its dedication – St Denis or Dionysus – being more usually associated with France. The upper view is taken from an old postcard, and the recent photograph was taken in April 2013.

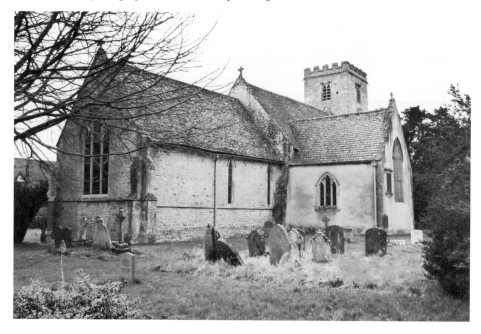

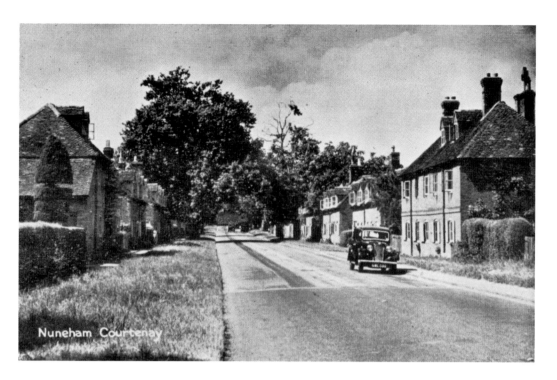

Nuneham Courtenay

Nuneham Courteney

Nuneham Courteney is an archetypal estate village that was rebuilt on a new site during the 1760s by Simon, the first Earl Harcourt (1714–77), because the original village was considered to be too close to his new house and park! The upper picture, dating from around 1950, shows the uniform red-brick cottages of the re-sited village, which extends along the busy A4074 road for a distance of about half a mile. The colour photograph was taken by Martin Loader from a position somewhat further to the north.

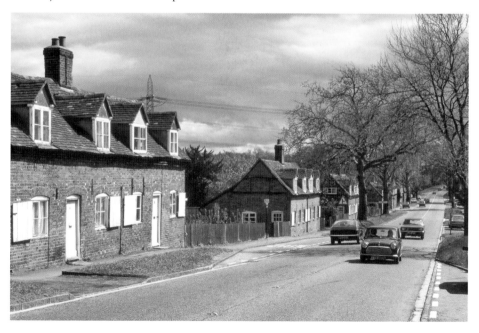

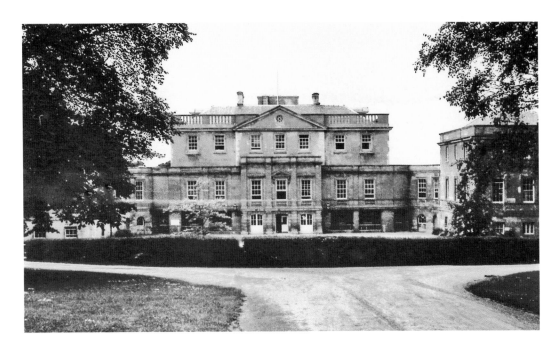

Nuneham Courteney

Above: Built by the Harcourts to replace their ancestral home at Stanton Harcourt, Nuneham House is a Palladian-style structure with a central block and flanking wings. Construction started in the 1750s, but various modifications have been carried out at various times – the result being something of a hotchpotch. The house is now a Global Retreat Centre, administered by the Brahma Kumaris World Spiritual University. *Below*: Situated within the park, All Saints church was built in 1764. Both of these photographs were taken in 1971.

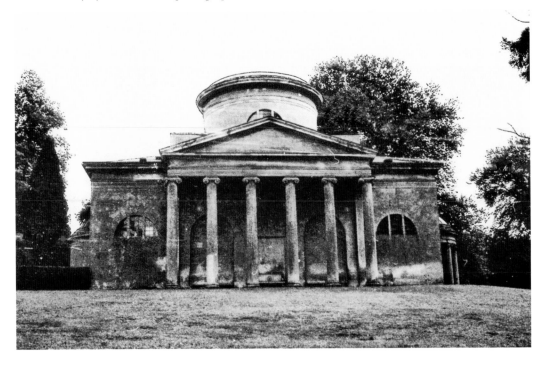

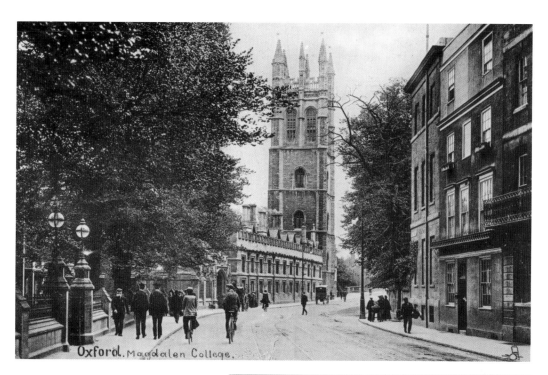

Oxford. Magdalen College.

Oxford: Two Classic Views

The photographs on this page illustrate two of Oxford's most famous buildings. The upper view, from a postcard of *c.* 1912, shows the eastern end of the High Street, with Magdalen College in the centre of the picture (this college will be described in greater detail on p. 70). The lower photograph depicts the Radcliffe Camera, which was completed in 1749. This distinctive building derives its name from Dr John Radcliffe (1650–1714), who left £40,000 to erect a new 'Physic Library', and a further sum to pay the salary of a librarian. The architect was James Gibbs (1681–1754), although the idea of a circular rotunda had already been suggested by Nicholas Hawksmoor; the eight large pedimented arches on the rusticated ground floor were originally open. The building has been used by the Bodleian Library as a reading room since 1860.

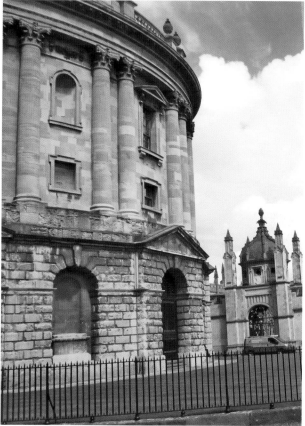

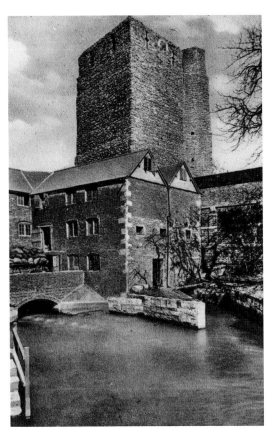

Oxford: St George's Tower

Oxford Castle was founded shortly after the Norman Conquest by Robert d'Oyly, who erected a motte-and-bailey castle with timber buildings, which were later replaced by permanent stone-built structures. The castle was a roughly circular fortress, with a tall stone keep on top of the Castle Mound; most of it was dismantled after the Civil War, but a prison and county court were built on the site during the 1840s. Five of the castle's six mural towers have been destroyed, but St George's Tower remains extant. It was, at one time, considered that the tower was of Saxon origin, while others have suggested that it may have been erected by the Normans to serve as a rudimentary keep, because the earth of the newly-raised motte was unable to bear the immense weight of a stone building. Although clearly of military origin, the tower also functioned as the bell-tower of the long-demolished castle chapel. The upper view shows St George's Tower from the north, probably during the early 1920s, while the colour photograph, taken in 2012, shows the tower from the west.

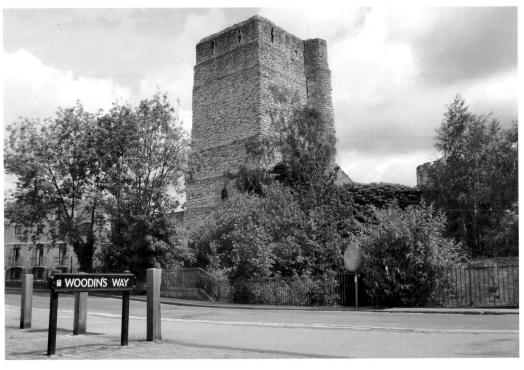

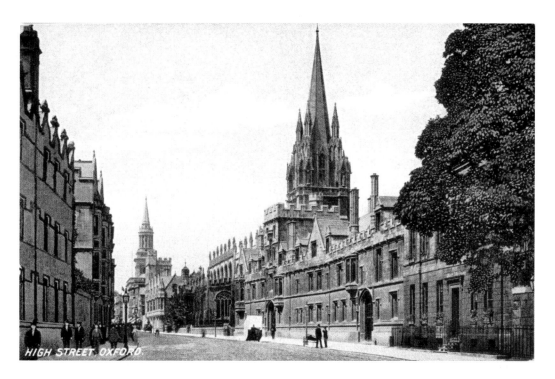

HIGH STREET, OXFORD.

Oxford: The High Street

Oxford's famous High Street, which contains some of the university's most famous colleges, has been called 'the noblest high street in the World'. This *c.* 1912 postcard provides a general view of 'The High', looking westwards, with St Mary's church and All Souls College to the right, and the spire of All Saints church visible in the background. The lower photograph, taken in 2012 from a position somewhat further to the east, provides a good view of Queen's College, while St Mary's church can be glimpsed in the background.

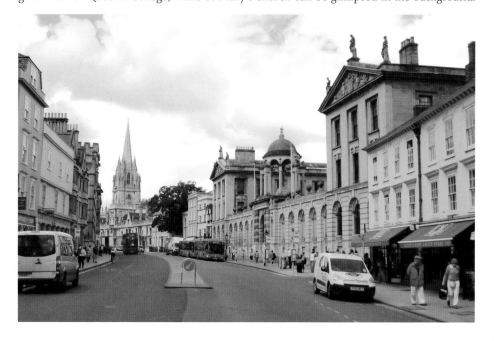

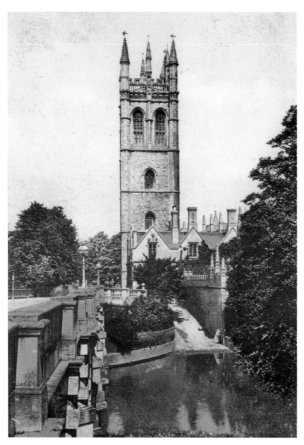

Oxford: Magdalen Tower & Bridge

Left: Rising majestically above the River Cherwell, Magdalen College Tower is one of Oxford's most iconic buildings. The College was founded by William Patten of Waynflete in Lincolnshire (*c.* 1400–86), Bishop of Winchester, in 1458, the dedication being a reflection of the Bishop's devotion to Saint Mary Magdalen. Construction commenced in 1467 and the main buildings, including the cloister and the famous tower, were completed by about 1509. The college buildings incorporate part of the Hospital of St John the Baptist, which had occupied part of the same site. *Below*: The present Magdalen Bridge, which has eleven arched spans of varying dimensions, was built in 1772–78, although further work was carried out in the 1790s. The bridge was widened in 1882 to provide sufficient room for the Oxford & District Tramway Company's 4-foot- gauge tram line.

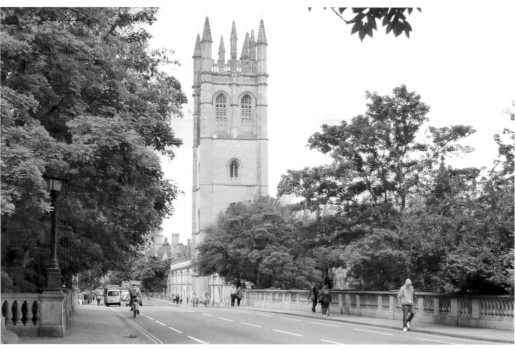

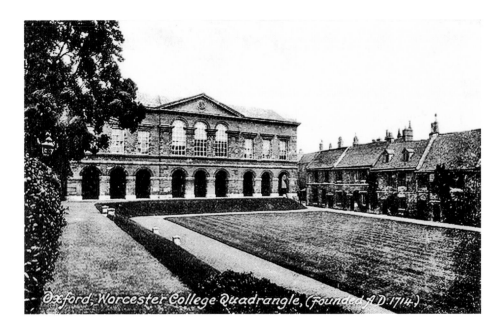

Oxford: Worcester College

Worcester College was built on the site of Gloucester Hall, which had been established in 1283 as a school for Benedictine monks. The college received its charter in 1714 after Sir Thomas Cookes (1648–1701) had bequeathed £10,000 to the university with the aim of founding a college for students from his native Worcestershire. Work commenced in 1720, but building operations were still under way during the 1790s. *Below*: Parts of Gloucester Hall have survived; the south side of the quadrangle is of fifteenth-century origin.

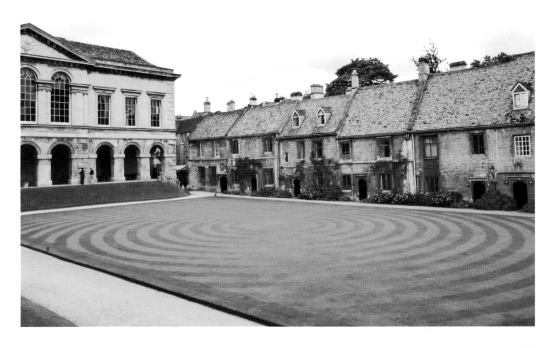

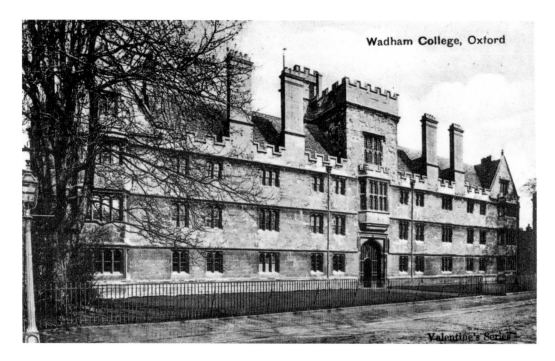

Wadham College, Oxford

Valentine's Series

Oxford: Wadham College

Wadham College was founded by Nicholas Wadham (1532/33–1609) and his wife Dorothy (1534/35–1618) who, as his executrix, obtained a royal letter patent in 1610 and undertook all of the work that was required to bring the scheme to a successful completion by 1613, when the new college was opened. The upper view shows the main façade of the Front Quadrangle, *c.* 1912, while the colour photograph was taken in May 2013 from a similar vantage point in Parks Road.

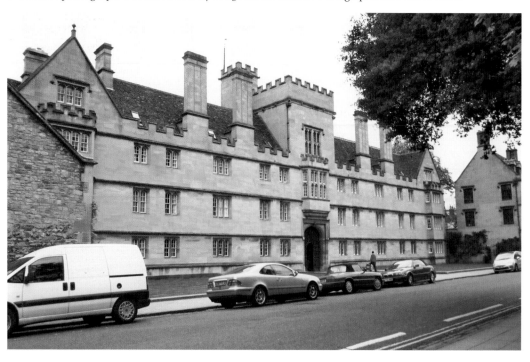

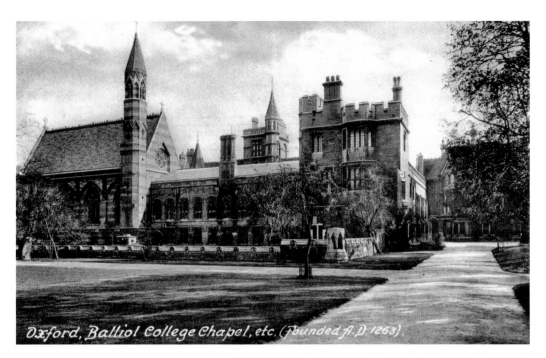

Oxford, Balliol College Chapel, etc. (Founded A.D. 1263).

Oxford: Balliol College

Balliol College was founded around 1263 by John de Balliol (*c.* 1200–68) of Barnard Castle, the father of King John of Scotland, in penance for an attack upon the Bishop of Durham. The college was intended to serve as a hostel for poor students, but it became a conventional college during the fourteenth century. Balliol boasts an immensely long frontage that extends from St Giles to Broad Street, the main Broad Street façade being in the 'Scottish Baronial' style. The upper photograph, taken from the 'Garden Quad' around 1912, is looking south-east towards the Victorian chapel, which was designed by William Butterfield (1814–1900) and completed in 1857 at a cost of £8,000. The recent colour photograph shows part of the Broad Street façade – this range of nineteenth-century buildings being immediately to the south of the chapel; the architect was Alfred Waterhouse (1830–1905).

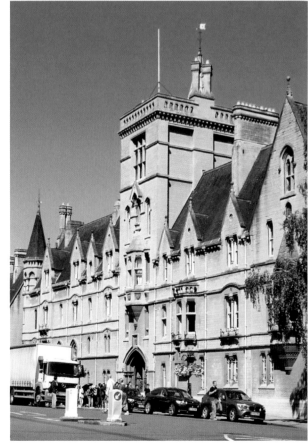

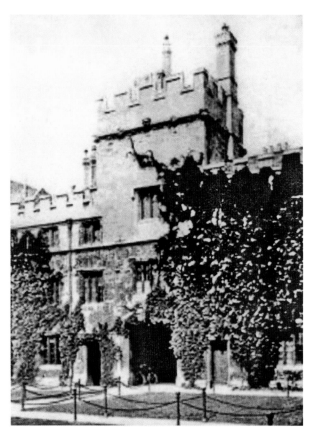

Oxford: Jesus College

Jesus College, in Turl Street, was founded by Elizabeth I in 1571 as the result of a petition from Hugh Price (*c.* 1495–1574), the Treasurer of St David's Cathedral. The college was, from its inception, intimately connected with the Principality of Wales, and many of its students and most of its benefactors have been Welshmen. There are two main quadrangles, together with an additional range of buildings flanking Ship Street, which were added during the early twentieth century. The upper view shows the interior of Front Quad around the 1920s, while the lower view shows the college from Market Street, the covered market being visible to the right of the picture. In common with other Oxford colleges, Jesus College is associated with many eminent people, among them T. E. Lawrence (1888–1935) and former Prime Minister Harold Wilson (1916–95).

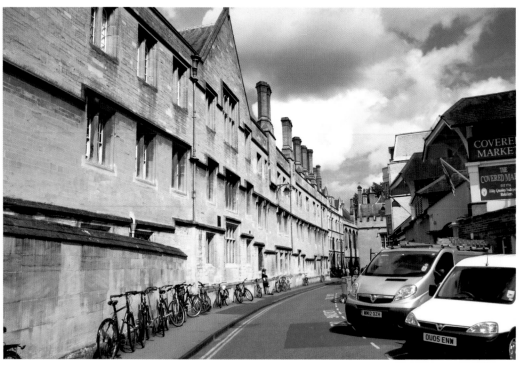

Oxford: St Edmund Hall

St Edmund Hall originated in the mid-thirteenth century as a hall of residence for undergraduates but it became a conventional college in 1957, having been granted a Charter of Incorporation by Queen Elizabeth II. In contrast to some of the neighbouring colleges, the buildings are small in scale, and have an intimate, domestic quality, as exemplified by the accompanying views of the North Quadrangle. The upper picture shows the south-east corner of the quadrangle, the building on the right being of twentieth-century origin, while the colour view shows the much older north range, parts of which date back to the 1590s; the flamboyant building with the giant Ionic columns was added *c.* 1680.

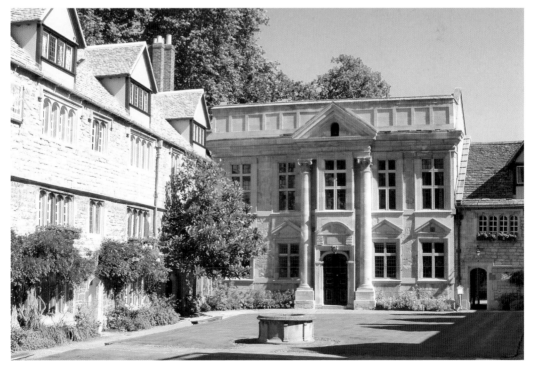

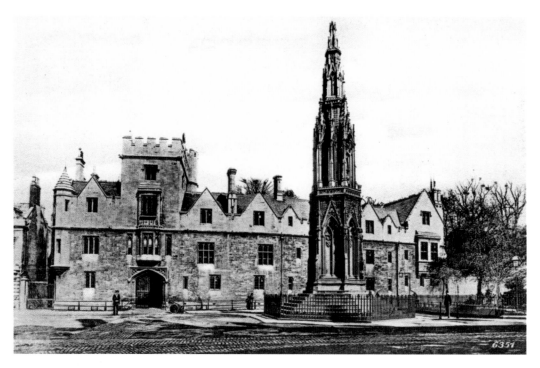

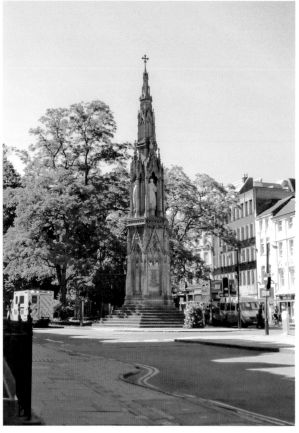

Oxford: Balliol College & The Martyrs' Memorial

The Martyrs' Memorial in St Giles was designed by Sir George Gilbert Scott, and erected in 1841–43 to commemorate Archbishop Thomas Cranmer (1489–1556), and bishops Hugh Latimer (*c.* 1485–1555) and Nicholas Ridley (*c.* 1502–55), who were burned to death during the reign of the Catholic Queen Mary. Archbishop Cranmer, who had been persuaded to sign a recantation renouncing the Protestant faith, famously held his right hand in the flames and watched it burn, saying 'this hand hath offended'; his final words are said to have been 'Lord Jesus, receive my spirit ... I see the heavens open and Jesus standing at the right hand of God.' The upper picture shows the memorial during the Victorian period, with Balliol College prominent in the background, while the colour photograph was taken in July 2012.

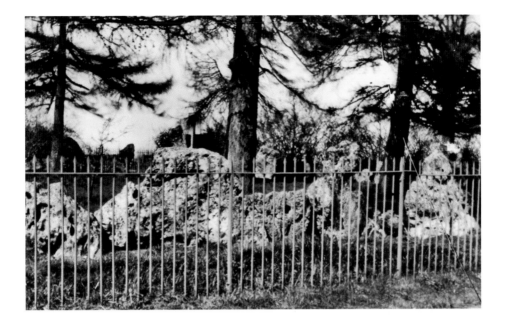

Rollright Stones

Perched upon on a remote hill above Great Rollright, near Chipping Norton, the stone circles known as 'The Rollright Stones' are as mysterious as the monuments at Stonehenge and Avebury. The Stones consist of two circles, one about 100 feet in diameter, while the other is about 6 feet across; these are known as 'The King's Men' and 'The Whispering Knights' respectively. The old postcard view depicts the entrance to the circle, while the colour photograph shows the circle in 2012.

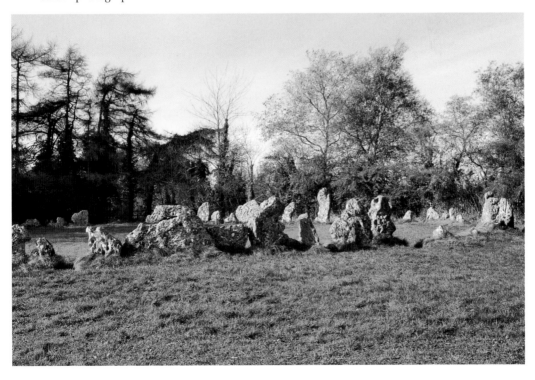

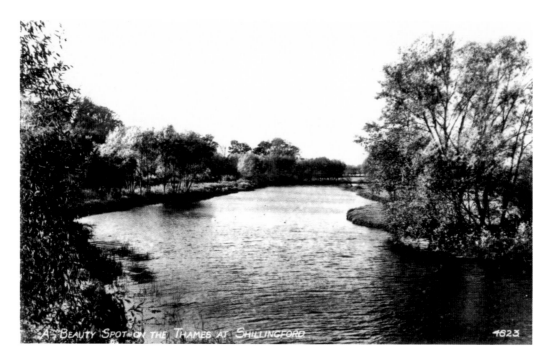

A BEAUTY SPOT ON THE THAMES AT SHILLINGFORD 4623

Shillingford & The Thames

Prior to local government reorganisation in 1974, the Thames had formed Oxfordshire's southern boundary for a distance of 71 miles – the great river being, in some respects, a sort of 'substitute coastline' for this inland county! The upper picture is looking upstream from Shillingford Bridge, probably during the 1930s, while the colour photograph shows a typical stretch of the river.

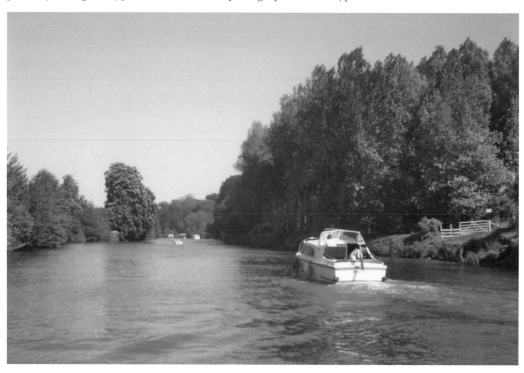

Shilton: The Ford

Situated in a secluded sitting amid steep, well-wooded hills, about 4½ miles to the north-west of Bampton, Shilton is an archetypal Cotswold village, with a twelfth-century church and a seventeenth-century manor house. The straggling main street has changed little over the years, the upper view being taken from an old postcard of *c.* 1912, while the lower view was photographed a century later, in May 2012.

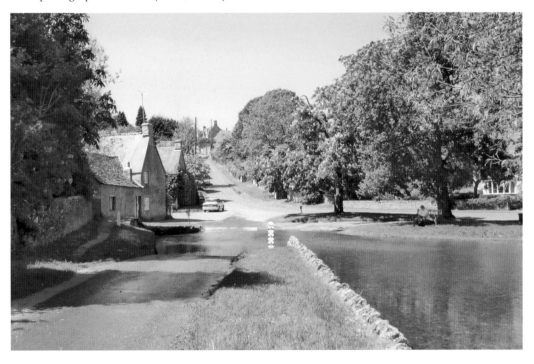

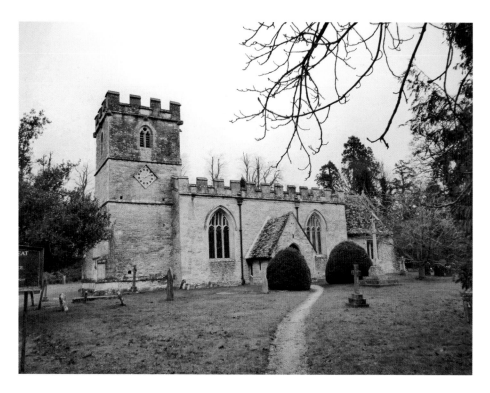

South Leigh: The Church of St James the Great

South Leigh was once a detached part of Stanton Harcourt, its original name being 'Stanton Leigh' but, in the fullness of time, it became an entirely separate village. The church of St James the Great dates mainly from the fifteenth century. It contains some famous medieval wall paintings, while a plaque on the early eighteenth-century pulpit recalls that John Wesley preached his first sermon here in 1725. The lower picture shows the church choir around 1925.

South Leigh: The Mason Arms

South Leigh consists of 'Church End' and 'Station End', the Mason Arms pub being conveniently sited roughly midway between these two dispersed settlements. Originally known as The Sibthorp Arms, it served as the village pub for many years, but has latterly been developed by its owner, Gerry Stonhill, as a top-class country restaurant. The upper picture shows the building in a state of picturesque disrepair around 1955, while the recent photograph shows the Mason Arms in its present-day condition.

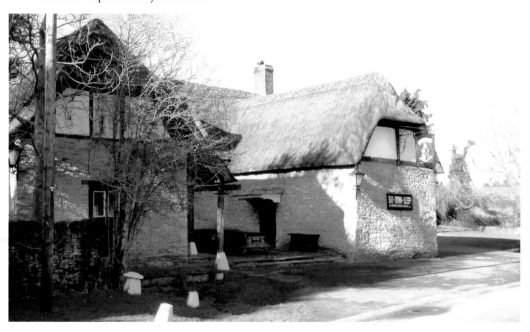

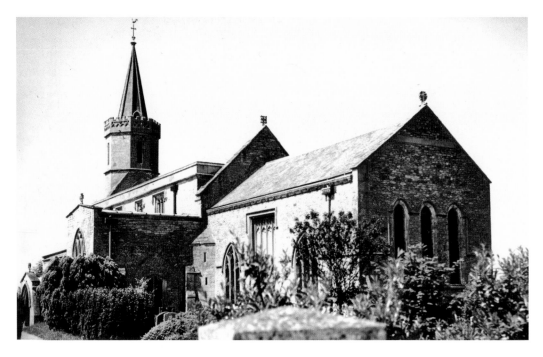

Standlake: St Giles Church

Standlake, some 5 miles to the south-west of Witney, is a stone-built village on the River Windrush, sited amid dead-flat water meadows. The parish church, dedicated to St Giles, is sited near the riverbank; it incorporates a nave, aisles, transepts and chancel, together with an octagonal tower surmounted by a miniature spire. The church was restored during the 1880s by the Witney architect Clapton Crabbe Rolfe (1845–1907), who added an elaborate wooden roof. The upper view is of *c.* 1930, while the colour photograph was taken in 2013.

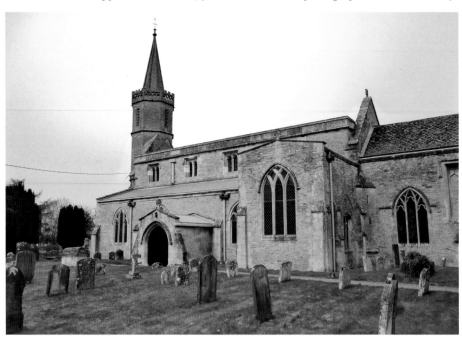

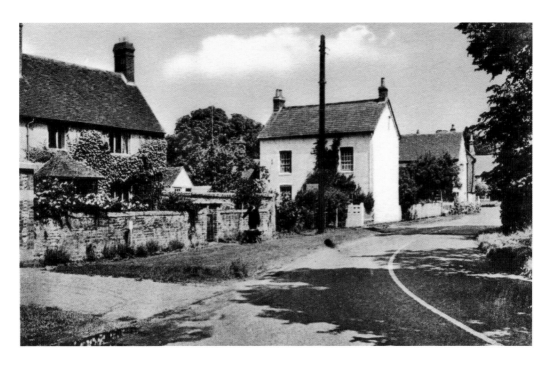

Warborough: Thame Road

Warborough, a large village about 10 miles to the south-east of Oxford, extends along the A329 Thame Road for a considerable distance, although there is also a very large green at the north end of the village. The upper view depicts part of Thame Road, possibly during the early 1950s, whereas the colour photograph was taken over sixty years later. Warborough has, like Dorchester, featured prominently in the popular ITV television series *Midsomer Murders*, several episodes having been filmed in the village.

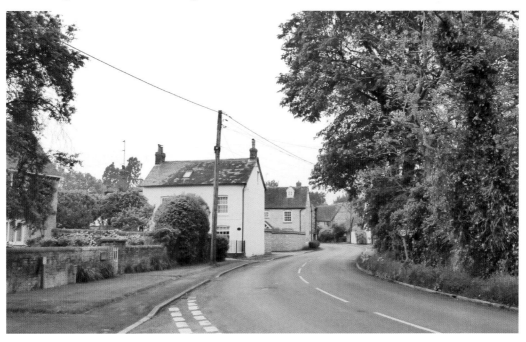

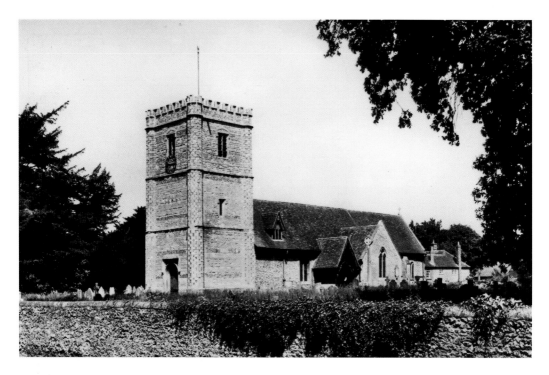

Warborough: St Lawrence's Church

The church of St Lawrence incorporates a nave, chancel and south transept, together with a north vestry and a decorative west tower with polygonal corner turrets. The nave and chancel are continuous, although an internal tympanum is provided above the altar screen. The tower, of three stages, is dated 1666, which is presumably when it was rebuilt; the wooden porch was added during the Victorian period. The upper view is from a *c.* 1950s postcard, and the colour photograph was taken in 2013.

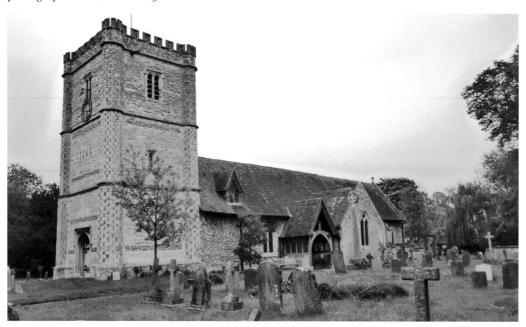

Watlington:
The Town Hall

Watlington is a pleasant market town sited at the foot of the Chilterns. These two pictures depict the distinctive brick-built Town Hall, which was erected in 1665. It is sited at the junction of High Street, Shirburn Street and Couching Street and served a dual purpose – the partly-open ground floor provided a covered market space, while the upper storey was used by the Watlington Free Grammar School. The sepia postcard dates from around 1920, and the recent photograph was taken eighty years later.

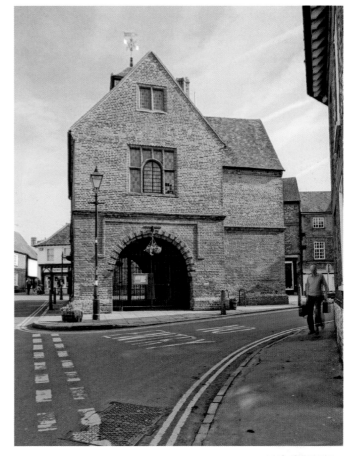

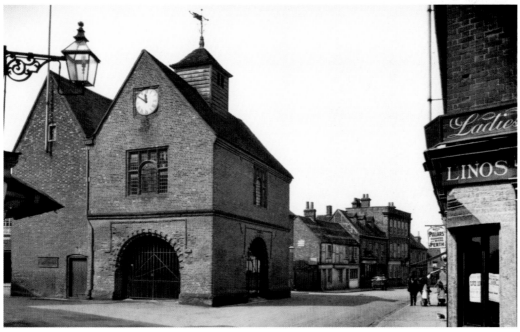

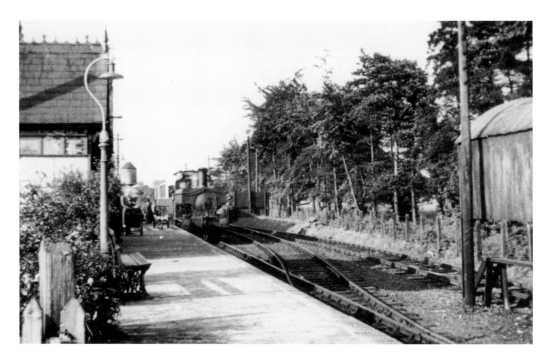

Watlington: The Watlington & Princes Risborough Railway

Watlington station was opened by the Watlington & Princes Risborough Railway on 15 August 1872 and, after a life of eighty-five years, the railway was closed to passengers in June 1957. Freight traffic continued for several years, and the line has now been revived as a 'heritage' railway – albeit on the easternmost section of the route between Chinnor and Thame Junction. The upper photograph shows Watlington station around 1930, while the colour picture, taken by Mike Marr in 2012, shows a train at Chinnor.

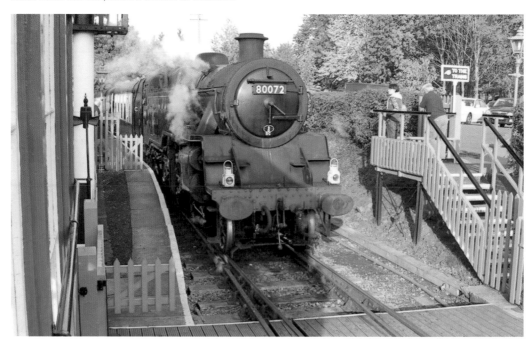

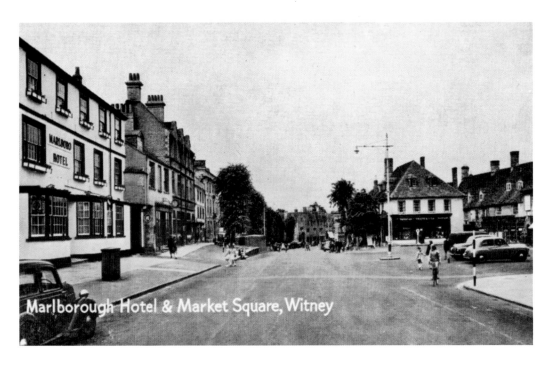

Marlborough Hotel & Market Square, Witney

Witney: Market Square

Witney was founded as an urban centre by the Bishop of Winchester who, as lord of the manor, was able to influence development in a number of ways. The spacious, wedge-shaped marketing area created by medieval town-planners around 1200 has dictated the layout of the town until the present day. The upper view shows the west side of the Market Square *c.* 1950, while the lower photograph, taken in December 2013, shows the square from a slightly different angle.

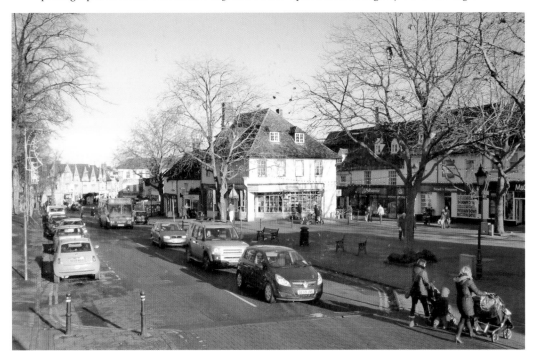

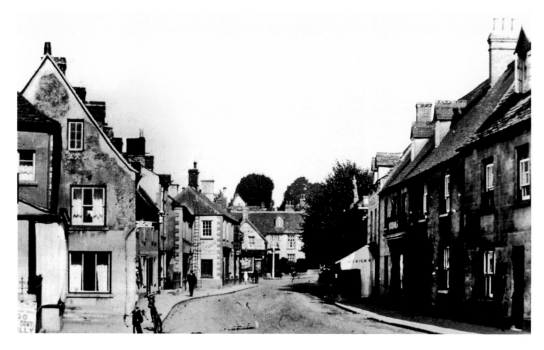

Witney: Bridge Street

Like other West Oxfordshire towns and villages, Witney is built predominantly of local stone, although many of its buildings are rendered with plaster and colour-washed, as seen in these two photographs of Bridge Street. The sepia view is an old postcard of *c.* 1920, while the colour photograph was taken in February 2013. Few changes have taken place in the intervening years, one obvious difference being the vast increase in the numbers of motor vehicles, which frequently cause traffic problems in this narrow street.

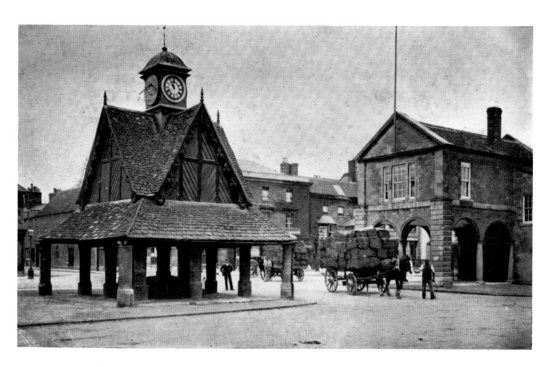

Witney: The Buttercross

Above: The famous Witney Buttercross is thought to have originated during the medieval period. Markets were originally held in the open air, but many market crosses were later provided with roofs, and in 1606, Richard Ashcombe, a gentleman of nearby Curbridge, left £50 to be 'bestowed and layed-out in the building of an house over and above the Crosse of Witney'. An inscription on the cupola refers to the installation of the clock by William Blake of Cogges in 1683. *Below*: A recent view of the Buttercross.

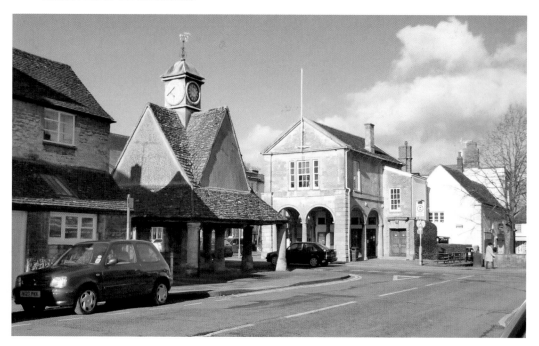

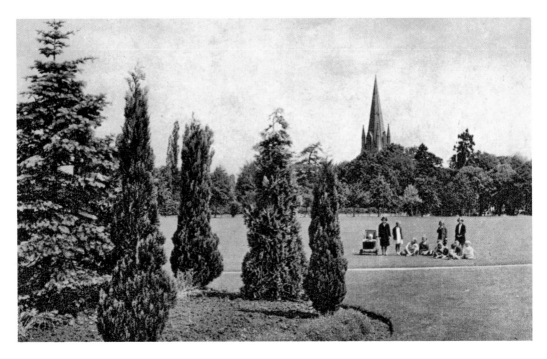

Witney: The Church Leys in Summer and Winter

The Church Leys, to the south of St Mary's parish church, were purchased from the ecclesiastical authorities in 1920 for the sum of £1,027 2s, in order to create a public recreation ground in memory of those who had given their lives in the Great War. The upper picture provides a glimpse of 'The Leys' *c.* 1930, while the colour photograph was taken on a bitterly cold day in January 2013. The 157-foot spire of St Mary's church features in both views.

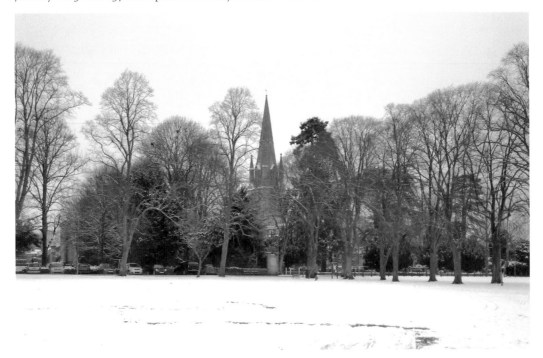

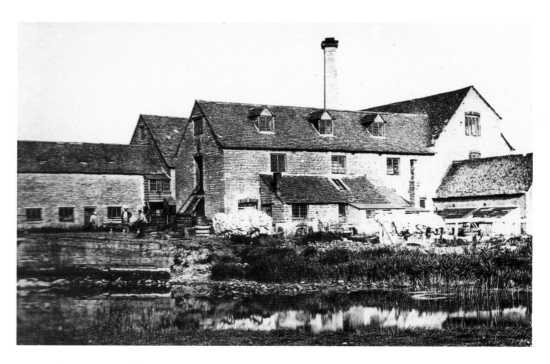

Witney: New Mills Then & Now

New Mill was used for blanket-making for many years. The property was reconstructed after a fire in 1883, parts of the earlier structure being incorporated into the new building. The mill came under the sole control of Charles Early & Co. after the fire, and it remained in full use until the 1950s, when Early's concentrated their spinning operations at nearby Witney Mill. Thereafter, New Mill fell into disuse, and the site was eventually relinquished. The pictures show the mill before the fire, and as it is today.

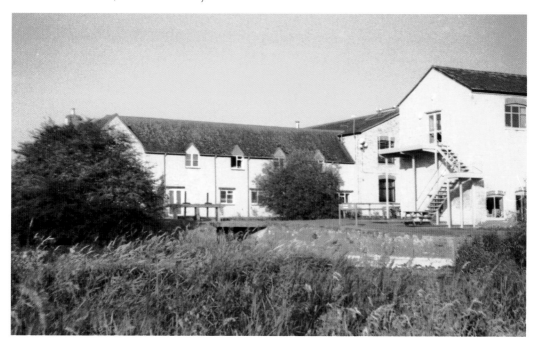

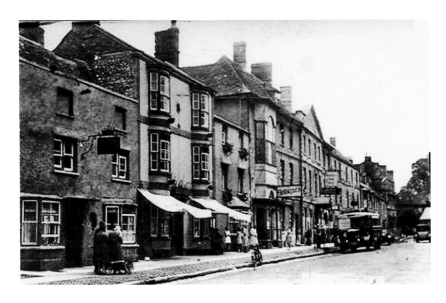

Woodstock: Oxford Road (The A44)

Woodstock was a royal manor in Saxon times, but it achieved greater prominence after the Norman Conquest when Henry I built a new royal palace and enclosed a 'park'. Urban development was further encouraged by Henry II, who laid out a new settlement to the south of the River Glyme – the original village, on the north bank, being dubbed 'Old Woodstock' to distinguish from the new town. The upper view shows Oxford Road around 1930, while the colour photograph was taken in 2013.

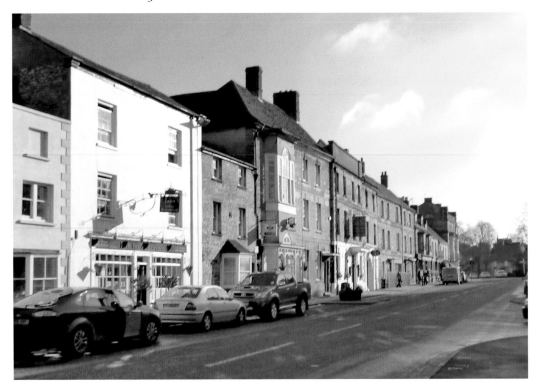

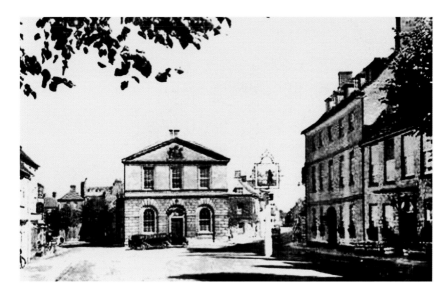

Woodstock: The Market Square & Town Hall

The Cotswold-stone Town Hall, which occupies a prominent position in Market Square, was designed by Sir William Chambers (1722–96). As originally constructed during the 1760s, it incorporated a council chamber over an open loggia, although the ground floor was enclosed in 1898. The sepia view shown above dates from around 1930, and the colour photograph was taken in January 2013.

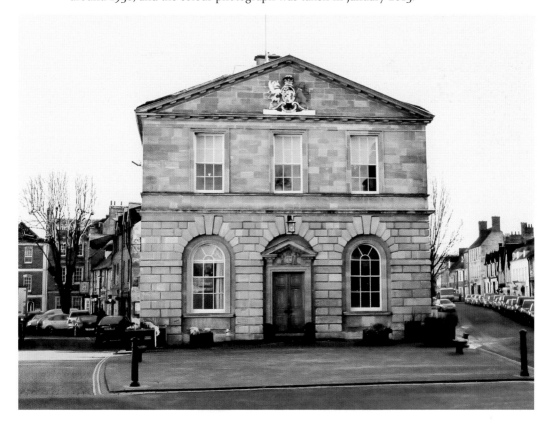

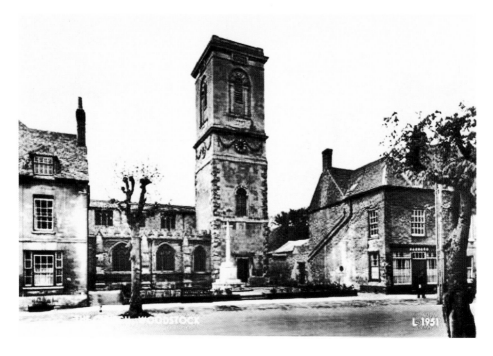

Woodstock: St Mary Magdalene Church

Woodstock church was, for many years, merely a chapel of ease, the parish church being at nearby Bladon. However, as Woodstock increased in importance, the church of St Mary Magdalene was extended and improved, a Baroque tower being added by John Yenn in 1785, while a substantial restoration was carried out by Sir Arthur Blomfield (1829–99) in 1878. The upper photograph shows the north side of the church, possibly during the 1950s, while the colour view depicts the south side of the building in 2013.

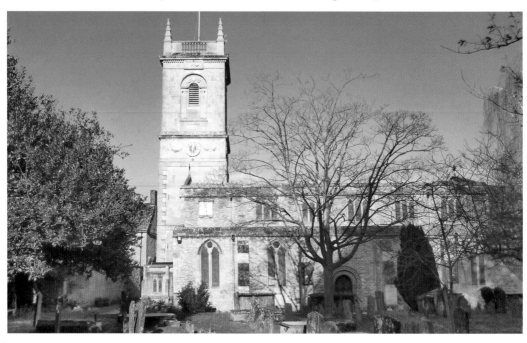

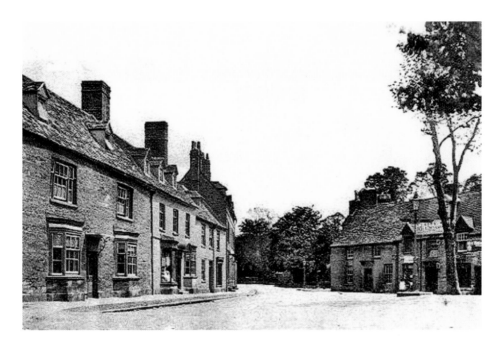

Woodstock: Old Buildings in Oxford Road

These two views illustrate a group of old buildings at the junction of Oxford Road and High Street, the sepia view being a postcard of *c.* 1910, whereas the colour photograph was taken in 2013. Despite the passage of over 100 years, there have been very few changes, apart from the vast increase in road traffic, which is almost incessant on the busy A44.

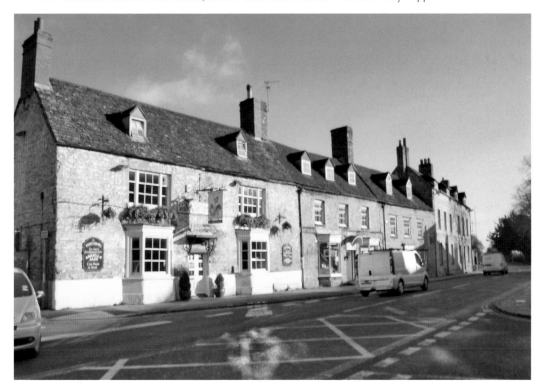

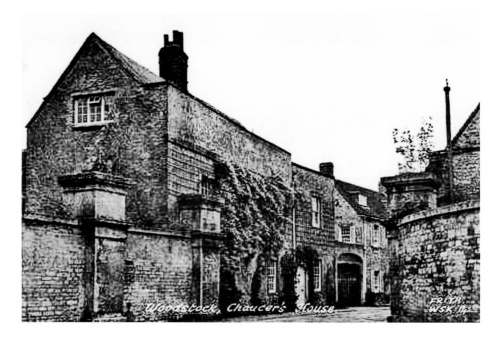

Woodstock: Chaucer's House

Two views of the old building known as 'Chaucer's House', at the west end of Park Street, which is said to have been occupied by Sir Thomas Chaucer (1367–1434), a royal official and the eldest son of Geoffrey Chaucer, although the present building appears to date mainly from the seventeenth and nineteenth centuries. The looming shadow that can be seen in the foreground of the lower view was cast by the neighbouring East Gateway of Blenheim Palace.

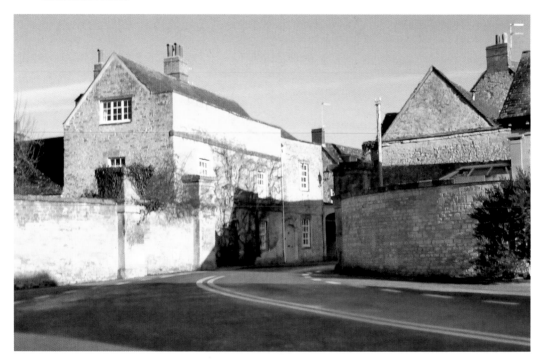